May 13th, 2015
9:47 pm

I'm not speaking to you right now, so I'm writing... writing down all the things I would tell you if you hadn't betrayed me. I can't trust you, and even though I could really use someone to talk to, I'm choosing an inanimate piece of paper over you. Hope that stings a little.

Well, if I'm being totally honest, this is for you. Whether you ever read it or not. Whether we ever talk to each other again or not... This is what I would tell you and I would start by saying...

Hello, friend...

You may wonder why I've put mysel~

I DON'T LIKE THAT HE'S WRITING ALL THIS TO YOU AND TRYING TO PUT ME IN THE DEEP FREEZE HERE, BUT I'M NOT TOO PROUD TO TAKE HELP WHERE I CAN GET IT. YOU'VE GOT TO TALK SOME SENSE INTO HIM. WE CANNOT BE STUCK IN THIS ANALOG NIGHTMARE. WE NEED TO GET BACK INTO THE GAME. YOU KNOW IT AND I KNOW IT. NOW WE JUST GOTTA MAKE HIM KNOW IT.

Obviously that was HIM. HE'S still mad at me for putting us in here. HE'S still fighting me and I'm... fighting back. Trying to, anyway.

May 14th, 2015
6:33 am

I am home. Well, what I'm calling home for the next 18 months and shit's getting real. Anxiety, panic, 100% founded fear for my life and my mind—all that has been consuming me for the past eight hours

in here. A cornucopia of terror and regret has set in. I know you might think I've gone full-blown insane to actually put myself in jail. But I have a plan. Sorta. I'm working on it. All I know is that faced with being locked away, it just felt right in the moment. I can't trust myself out there and until I can, I need to be cut off. No internet. No computers. Nothing for HIM to do but stare at four walls while I figure this shit out. Is it extreme? It's the definition of. But do I do anything any other way? And does HE?

Do you think I made the biggest mistake of my life doing this? If you do, you may not be wrong. I have no idea what to expect in here and I'm not such an idiot to think it's going to be rosy. The screams I heard from other inmates all night long have done a pretty solid job of putting me on edge. Not to mention that I actually have to |INTERACT| with all of these people on a daily basis. There is no escape from having people around ALL the time, everywhere I turn. It's fucking claustrophobic, but I'm trying to get used to it. I have to. I have no illusions (I know, funny coming from me) that this is some sort of touchy-feely safe space for me to find myself, but it's the only option I had and, scary or not. I have to take it. I hope I can make it through this.

But, like I said, it's not like HE'LL cooperate in any other rational way. HE'S still refusing to tell me anything that happened that night— especially where Tyrell is — so I gotta hold firm. If HE'S not talking, I'm not walking. It's that simple. So, I gotta go to the brink to get to the other side. You understand, don't you? I mean, if I am crazy, the only way to beat it is with crazy. So that's where I stand on it. We'll see how this turns out.

EAT A...

Weird to think he doesn't remember
the first time we really met this
day. Guess it was HIM and not
Elliot anyway... Is there a difference?
Elliot thinks so, but is Elliot

1:45 pm

FUCK. I just came to and I'm back in my cell. I don't
remember breakfast, kitchen duty or lunch. Shit. This brings to
light a huge fucking flaw in this plan: I don't want HIM
loose in here with these other criminals. Whatever it takes,
I cannot let HIM take over. I have to keep control. If
I can do that, HE can draw all the dicks HE wants and
it won't matter till HE'S honest with me. Anyway, I
just have to stick to a little thing lame self-helpers like
to call "fake it till you make it." Speaking of pretending...
Well... it's sort of hard to explain, but... Well, I'll
just say it and you can make of it what you want.

Okay, so when I checked in yesterday and I walked down
these dingy halls and got to my beyond-fucking-bleak new
bachelor pad, I pretty much fucking lost it... on the
inside. My brain was starting to melt down at the
giant fucking ramifications of the the reality I have forced
myself into. I'm definitely doubting if I did the right thing.
Look, it felt really good to pretty much say fuck you
right to HIS face during my sentencing, and if I'm being
totally honest with you, I think I sort of hoped HE would
just go away while I was in here. That maybe, by
being locked away, I could sever ties from everything,
including HIM. Like a panacea or something. Clearly that
was an irrational pipe dream. So... when I got in here, I
did all I could do to make it through. I just found it all
a little easier to handle if I imagined my surroundings
differently. More specifically, I've mentally turned this
place into my mother's house. It's just a way to cope.

the whole or merely a divided part? Not sure I know the answer to that.
Anyway, all HE said was HE liked my blue eyeshadow. HE was probably
being sarcastic, but I took the compliment because I was needing one that day.

I guess it's better than morphine. Right? Don't answer that. It just helps, is all I know, and I don't want to get into it any deeper than that. You can make your own psychological assessments on your own time. But I will explain how I see it. Probably best to draw it out.

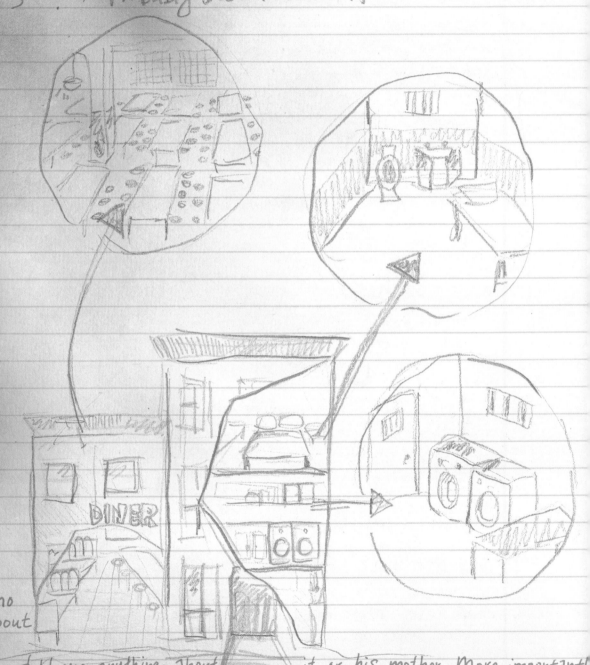

I had no idea about this.

He never told me anything about ___ it or his mother. More importantl[y] how can he turn Hollister into ___ his mom?! She's so mean. But I guess his moms didn't sound like much of a peach neither.

10:26 pm

It's crazy how one little word can change your whole life:
guilty. That's all I had to say to shock the shit outta
everyone around me and piss HIM off beyond belief.
Like I said, it felt good. Though they don't know it,
I'm guilty of so much more than stealing a dog and
saving Krista from even worse heartbreak than my
actions caused her. So it felt good to say it out
loud to someone... even if they don't know what
I'm really saying.

Shit. Remember when I first met you and I
thought MAYBE I was crazy? NOW I'm full-
fledged, right? Whatever this is I have. It's fucking
madness. I'm seeing and hearing HIM. I mean,
look, I know you were there, you saw the whole
thing. And there's a part of me that felt like you
knew the whole time— but I won't get into it (asshole).
Bottom line is, how the hell do I become normal after
this? Is it possible? Am I just doomed to be nuts the
rest of my life? Is there any way to come back
from this? Can I later down the road be a normal
person with a wife and a dog and tell my kids the story
about the one time I lost my FUCKING mind and started
seeing... I can't think about this anymore. I have
to think about something else.

Flipper. She really started to grow on me once she
stopped pissing on my pillow, and I hate the idea that
she's going back to that asshole Lenny Shannon.
Maybe, after all this, he'll learn he should treat
her right. The least he could do is treat one of the
women in his life right. Yeah, I know, he's gonna
keep treating her like shit just like he does everyone
else. Everything sucks.

Krista... I haven't seen her since that last session. You were there... The big confession. Should I try to write her a letter and apologize? I also want to see if there's any shred of her that would ever even consider still meeting with me. I know, she might be a little fucking pissed at me right now, but she's an optimist and I think that, deep down, she still thinks she could help me. I could use some of that help right now — that positive energy for change or whatever bullshit they're calling it these days. Plus, I'll take any help I can get with my "problem." That's what it's come to, and that's why this is going on — me scribbling down my thoughts and putting them out into the ether to see if there's some semblance of control to be had.

See, I met this kid Leon the first day I was here. He was the one who got me this book and pencil. He seems innocent enough and it doesn't hurt to have someone show you the ropes, but I gotta keep him at a distance. I'm not falling into any traps of trusting anyone, and I don't need any friends. I'm better off solo for my stay. In fact, I NEED to be solo. I will say that Leon does seem to be okay with doing all the talking and he isn't thrown off like most people when I just sit there and don't say shit. I think he was a little disappointed I didn't take him up on his offer of grandma porn, though. One thing he got into was telling me about surviving in here and how he's all for establishing a routine, getting yourself into the cycle of the mundane, and it hit me that this journaling bullshit could help. I mean, therapists are always harping on how writing stuff down helps with deciphering patterns of behavior and working to change them, so here I go — writing bullshit down with fingers crossed that I can get rid of my insane, impulsive ████████ father who causes me to

get myself and everyone I know into trouble

And really, who am I kidding? I've got absolutely nothing else to do with my time for the next 18 months. Might as well blab to these pages here. But will it actually help in the long run? I mean, really, isn't this just glorified mental masturbation? What do you truly get out of writing in these journals other than your own self-indulgence times infinity? Despite that, I'll press on.

Okay, not sure how to end one of these entries. Peace? Until next time? TTFN? How about...

Major Tom, signing off.

Jesus fucking Christ. that's lamer than "Hello, friend."

May 15
9:57 am

Blah blah, blah, BLAH, bbbllhadhbhh...
It's like day two of doing this and I already don't feel like writing a thing. I found a book in the library about how to journal. Yeah, don't worry, I didn't let anyone see me reading it! But they say even if you don't want to, just keep doing it. Keep going and just write. Write anything that comes to your mind, just write nonsense, nothing, so...
NOTHING NOTHING

All right, I won't just make this entry a jerk-off. I'll try and "share" some shit. What I'm trying not to say, because I don't want to think about it anymore and I don't want to be a broken record, is that I'm still not 100% on being here. It's also not helping that HE'S in a full-scale attack mode. I "woke up" today already eating breakfast. The previously fine line between when I'm awake and when I'm dreaming is getting fuzzier and fuzzier. That's HIS intention—to get me off balance—and it's working. FUCK. I know, you're thinking it too... this is going to be so much harder than I thought.

It's even more depressing when HE keeps telling me that HE knows it's only a matter of time. HE said HE should just sit back and enjoy the jumpsuits 'cause I'm gonna crack on my ~~own~~ own anyway. HE thinks I won't be able to handle it—that there's no way I'll accept this mediocre existence. Maybe HE'S right. Am I gonna look back at kicking morphine and think it was cake compared to this? Not gonna lie, I already kinda miss my life and I don't know if it feels like I even have one in here. I feel like a zombie locked in a fake video-game world with a bunch of other zombies living out a simulated existence controlled by our Matrix-esque robot overlords. Am I even really awake right now? Did this all really happen??

Maybe I gotta cut myself a little slack ... not only am I figuring out what it is I've just done to myself here. I'm still processing everything that's been happening over the past few days—shit, the past SIX MONTHS.... and it all begins and ends with HIM. I still sorta can't believe it, though I totally believe it. It all makes perfect sense. What doesn't make sense is if I caused this—all of it—

why can't I get rid of HIM too? How does HE have such a strong hold on me... Why do I let HIM?

1:27 pm

So, Leon keeps following me around. For some reason, he's taken a liking to me—or he has an ulterior motive. I always seem to find a shadow. Speaking of which, HE's still hanging around. And HE's fucking mad! Like right now HE's just singing "It's The End of the World as We Know It" over and over again. Yeah, I agree, not incredibly original and definitely on the nose, but what HE doesn't know is that I'm starting to get used to the rhythm of the repetitiveness and it's very relaxing, actually. HIS singing voice, on the other hand... well, let's just say HE's not going to be starring in any musicals at the Hollywood Bowl anytime soon.

So far it's pretty nice to be on the giving end—being the one of us who's driving the other one crazy. Maybe I could get used to this and agree with Leon. Maybe the ~~XXXX~~ monotony is just fine. Maybe I'll even go to the basketball court with him in a little bit. That's a lotta maybes, but... I'm trying...

Oh, got a letter today. Well, not exactly a letter. It was just a blank sheet of paper with my address on it, inside an envelope. Not sure what it means, but I definitely don't trust it. Maybe it was a bureaucratic mix-up. Maybe it was my Welcome to your Life of Incarceration packet and some drone in the communications center got consumed with whatever dumb UFC fight was on that day and forgot to put the actual letter in before sealing it up. That's the only explanation I can come up with right now.

So weird, right?

9:21 PM

I've got it. I did end up at the game with Leon, and I figured it out. HE tried to disrupt things by taking over again. It was really weird this time 'cause HE did it really quickly. Like I was sitting there, watching the game, and then — nothing. Then, I came back and the game was just ending. It totally fucks with my mind to have Leon talking about something and then just pick up at the very end of what he's saying. It's like falling asleep during a movie and waking up when the next movie has started and you have no idea what story you're in. Anyway. Though I'm sure HE thought HE was getting a good dig at me by taking over, it actually further drove my revelation from my basketball-inspired train of thought. |RULES| I mean, the rules of that game are totally lost on me, but I will acknowledge that those guys running around are following something that tells them what to do and when to do it. So that's what I'm gonna do. I'm gonna make my own set of rules to follow — strict and regimented to keep myself on a path — to keep myself from being distracted, tricked or used by HIM. I'm gonna freeze that motherfucker out and you're gonna help me.

Here's the plan and it's simple:
Every day I'm going to do the exact same thing at the exact same time. Establish a routine that I will not break under any circumstances. Every minute planned and accounted for. That shouldn't be too hard in a place that already has a boring-ass routine set up for me. And I'm going to keep track of every single thing here in this journal. Everything recorded, time-stamped and in print. There will be no chance for HIM to steal time without me knowing it.

Here is the regimen:

	
6:30 am	Wake up
8:00 am	Breakfast
10:00 am	Kitchen duty
12:00 pm	Lunch
2:00 pm	Rec time
4:30 pm	Laundry duty
6:00 pm	Dinner
TBD	Other activity
10:30 pm	Lights out

HE is laughing at me, but I can tell HE's kind of scared, too.

May 16
6:30 am

So it begins. The regimen. I like calling it that. It sounds very legit. I think most people start out on a new routine will all this hope that this could be it!! This could be the thing that changes your life!!!! Not me. I'm pretty sure I'm gonna bomb the fuck out of this, but that's not gonna stop me from trying and ignoring every instinct that's yelling for me to stop all this bullshit right now.

9:15 am

Leon found me at breakfast again. I'm pretty sure this is going to be a regular thing. Anyway, while we were trying to get our food, one guy — well, I say "guy" but it's Hot Carla, who Leon told me is transgender. When I first saw her in here, it shocked the shit outta me. It's hard to tell she's not a girl until you get really, really close up. Anyway, she busted another guy's cheek open with a cafeteria tray right in front of me! I had to duck to miss the second swing she took at him or else I would've been fucked up. Shit, even if you're minding your own business around here, just waiting for your Salisbury steak, you still get caught up in other people's bullshit. The other inmates were getting pretty riled and then HE came right up to me, yelling about what a mess I've gotten us into and how it's basically a life-or-death struggle to survive each day in here no matter what I do. HE actually seemed scared, and HE rarely gets that rattled. So, of course, that freaked me out more. I guess that's what HE wanted. Finally, the guards got everyone in check. They're used to it — aggression. What do they expect when they corral a buncha exceptionally hostile individuals into one bland,

Here's my grand entrance into Eliot's world. I can't decide if it's totally embarrassing or sorta badass?

mind-numbing institution? Shit's gonna blow. The weirder part is how quickly everything just goes back to normal and the blood is just hosed off the floor like nothing happened. Everyone just went right back to chowing down and laughing it up. Fucking surreal.

Leon said that guy's been asking for it from Hot Carla. He (and lots of others around here) don't leave her alone much — for obvious reasons. So in that case, good for her for taking a swing — I'm just glad I ducked in time. Maybe my reflexes are just on high alert since you can feel the tension between people in here and no one needs much of a reason to fuck someone else up. It's a super weird vibe. Movies don't totally get it wrong. There are groups of gangs and race lines drawn between prisoners just like they say. It's not that much different from the outside. Everyone's trying to survive and finding their people to help them do it. I'm just trying to do it with as few people as possible — to be alone. Look, I'm not saying that's the way to live. You know there are always gonna be those people I keep close — so, okay, other than those people. Loneliness is the only thing I know. Especially in here. No vulnerabilities and no alliances. I think that'll keep me safe, right? I dunno, maybe I do need someone to back me up if someone comes at me with a tray one day. I guess for most people it's scary to be on their own, but that's the only way I know and I'm gonna go with it. Though I will admit, Leon's sorta worming his way in. Fuck, I really fucked up by coming in here. Didn't I? Understatement of the

NOM NOM

1:27 pm
The last thing I remember was writing about Leon worming in and now I see this.

Since I'm being totally honest here, I'll admit that this guy got it from me because he stole one of my lipsticks — not for the other reason Elliot thought. I may be the one and only ME around here,

HE's fucking with me. HE wants me to know HE's still able to take over. HE's flexing HIS muscles to show I can't beat HIM. What I want to know is, what the fuck was HE doing? Like I said, this is an ideal playground for a psychopath like HIM. He cannot go unsupervised. He always has another agenda. Am I go playing right into HIS hand? Shit, he could actually want to be here and HE's reverse-psychologied me into all of this. I probably shouldn't even be writing anything in here— HE could just be reading it and using it all against me. And what does all that drawing mean? It's ouroboros of course, but is the obvious reference the one he's intending? Or is there more to it? Part of me wants to ignore it since HE could just be doing HIS own worming into my brain, but... what if it is something important? What if there is some message there? I've been racking my mind to make sense of it. I haven't found anything else HE's written in here or anywhere else in the cell, but I'm going to keep an eye out. Right now what I can do is go find Leon. Yeah, I know what you're thinking, but stop. I'm still alone. I just happen to find him entertaining. That's all. Leon is NOT a friend.

4:03 pm

Add enlightening to that. Leon was with HIM at lunch. Apparently, when Leon was mid-conversation about the latest Mad About You episode... Oh, Leon is currently going through different DVD box sets they let you watch on the computers in the library and he is doing a deep fucking dive into Mad About You. Anyway, as Leon was pontificating about the shenanigans of Jamie and Paul's relationship, HE interrupted and launched into

HIS own little diatribe against the idea of monogamy. HE really let loose on the institution of marriage and how Jamie and Paul are trapped in a downward spiral, chained to one another for an eternity of bitterness and unfulfilled desire. Probably not the light lunch convo Leon was expecting. While he did give me a whole earful on how HIS/my points were somewhat valid, Leon had quite the long list on the counter side of that argument. At the end of that very detailed list, though, Leon did say he thinks the species will evolve to one that becomes more comfortable with open relationships as a means of maintaining a more lasting union.

Somewhere during his explanation, I realized that I need a name for this journal here. I mean, I don't HAVE to give it a name. I'm not claiming this is the work of Rimbaud or something, but it feels a little naked without one. So, right now, I'm going to come up with one. First thing that comes to mind. Hold on.

There it is. Ten seconds ago, I wrote "Red Wheelbarrow" on the cover. Basically, the first thing that came into my mind. It felt like an impulse, almost. Strange because lately I've had a thing for wheelbarrows. Red ones. I catch myself drawing them sometimes. Does it have something to do with HIM? Something HE's got on the brain that I'm catching on to? Oh, I haven't drawn you anything outside of the townhouse that I've created in my mind, so I'll do that now and show you how I'm seeing everything.

I'm going to come right out and say it, I don't know what the fuck Red Wheelbarrow means.

Anyway, that was a distraction from retracing HIS steps, but that's really all I got. Leon didn't know where HE/I went after lunch, so that leaves about... two hours and 45 minutes unaccounted for. Plenty of time for trouble, but I can't figure out what else HE did. Of course, I'd ask HIM if I could, but HE'S been conveniently absent. It's unsettling... puts me in a place where I don't know if someone's gonna be coming at me any minute for something HE'S done or some deal HE'S made to fuck my shit up. But... what's even worse is what I don't find out. I'd rather HIM piss off some giant skinhead to get him to kick my ass than legit take over in order to hide something from me. That's what I'm really afraid of, because anything HE'S totally keeping from me, well, that's the really bad shit.

5:47 pm

Still no sign of HIM. I'm just keeping it business as usual. Thought one weird thing happened during laundry duty. I went back into the cage where they keep the extra linens and stuff and I heard someone crying. I went in a little further and saw Hot Carla hiding huddled in a corner back there. She was pretty banged up and bleeding, and she got really scared when she saw me. I wasn't sure what to do. At first I thought I should just leave her alone, but I felt bad for her. So I kinda tried to tell her it was okay, that I'd leave her alone if she wanted or we could talk or whatever. She just sat there and stared at me. She did this for like a long time— kind of like she didn't even understand what I'd said. I waited a while and then, when I asked if she was okay, she just jumped up and punched me before running away. It was weird. I mean, the punch hurt, of course— she got me right in the nose— but I was kinda okay with taking it. I could tell it was like she wanted to

I don't really want to talk about this.

punch someone else—whoever'd done that shit to her—but she couldn't. So when I was offering to help, I guess that's what she needed. And I'm okay with that. I'm pretty sure I'd rather take a punch than talk about feelings and shit, so I hope it made her feel better.

8:47 pm

At dinner I was on high alert and could hardly eat. Can't have an appetite when I'm still wondering if HE has some plan of attack that's gonna hit me any minute. Thankfully all was clear. Fucking sucks... can't live with HIM, can't live without HIM. When HE'S around, HE'S bitching at me, when HE'S gone, the paranoia skyrockets. Either way, HE'S fucking with me.

After dinner I was walking past the guard stand and I saw on TV that Dateline was doing an in-depth look into the life of Tyrell Wellick, enemy #1. It seems impossible that the whole world is looking for this guy and can't find him. Well, the same coulda been said for the hunt for Bin Laden and look how long that took. But he had caves and a whole network hiding him Tyrell doesn't have all that. On the other hand, studies show that if that many people know a secret, it'll get out faster. So maybe Tyrell has a better chance of hiding for longer since he has to be pretty much on his own. Maybe only the Sutherland guy knows where he is, and that dude isn't talking. Or maybe no one knows where he's living because he isn't living anywhere. Another case of too many maybes, and I think I do know one person who knows the truth. I wish HE would tell me what happened that night. Popcorn. That's all I remember, and then just ... blackness. I can't seem to push past that and it's fucking driving me crazy.

I need answers, but until I can get some outta HIM, HE'LL just have to suffer the regimen.

Speaking of, I might've found another activity to add. I peeked in on the holy rollers group tonight. They meet almost every night, but I don't think I could stomach that. Maybe twice a week I could add it in, for entertainment value. Plus the added fact that

A LINE MUST BE DRAWN. HE AND I ARE AT WAR, BUT NOW HE'S TURNING TO GOD?!? THIS KID'S MORE FUCKED UP THAN I THOUGHT. YOU SEE THAT HE NEEDS ME, RIGHT? YOU CAN'T JUST STAND BY AND WATCH HIM GET CAUGHT UP IN THIS, AND IF YOU DON'T, I WILL. IT'S MY JOB TO PROTECT HIM AND YOU CAN BET YER ASS I'M NOT GONNA LIE DOWN AND GIVE HIM OVER TO THE HIGH HOLY ONE. THOSE JESUS FREAKS ARE GONNA LOVE EXPLOITING THIS KID'S DESPERATION AND TURNING HIS BRAIN INTO SWISS CHEESE. NEXT THING YOU KNOW THEY'RE GONNA BE DUNKING HIM IN WATER OR SMACKING HIM ON THE HEAD TO GET THE DEMON OUT... AND WE ALL KNOW WHO GETS DEMONIZED IN THIS SCENARIO. YOURS TRULY. JUST 'CAUSE I DON'T BELIEVE IN CONFORMING TO THEIR FOLLOW-THE-HERD MENTALITY AND THEIR MIND-NUMBING DO-UNTO-OTHERS BULLSHIT. "OTHERS" DON'T EVEN KNOW WHAT IS BEST TO BE DONE. SOMEONE NEEDS TO STEP UP AND DO WHAT NEEDS TO BE DONE FOR THEM.

HE did it again. HE won't face me, but HE'LL scribble this in my journal, hoping to communicate to you, but not to me? Doesn't make sense. Does HE not know we're not talking right now? That you'll only be reading this when it's too late? When whatever will happens here will have already happened? Interesting that that's what it takes to get HIM back. Just toss in a little threat of Jesus and the devil goes on a PR campaign to defend HIMSELF. Good to know! I'm getting to HIM. It's working. Any time HE gets that upset, I know I'm doing something right.

I wrote to agree ... but those religious freaks are the worst. Hypocrites, all of them.

May 17
6:38 am

There's a song stuck in my head. I cant remember it—it's on the tip of my tongue, though. I had a dream about it last night. It was my first date with Shayla. We went on a ride on the ferris wheel in Coney Island. Her idea, not mine. She had seen that Polaroid of me out there and thought she'd surprise me with it. It didn't go over well. I was an asshole to her— I don't want to talk about it anymore. She's dead because of me, and I still fucking hate myself for it. Something else in the dream:

I was running through a maze and I couldn't escape it. Finally, at the end, I started to float above it. I think I was starting to have one of those lucid dreams where you can control everything. So I decided to fly out of the maze. But the strange part was—when I was high above it, the maze—it looked like a QR code.

9:23 am

I kinda can't stop thinking about Hot Carla. There's something...
I dunno. I feel a little lost without my usual digital weapon of
choice to dig into a person's life and what's going on with
them. It's pretty clear what's going on with her, and it's
fucked. No one deserves the shit she's having to take from
these goddamn morons. And, yeah, I know, I know, I'm
supposed to stop doing all that kind of digging and getting
involved in people's problems, but... maybe I'll just snoop around a
little. Just follow her some to see what's what. A little IRL
investigating can't hurt. In fact, I could argue that it's actually
healthy and a proper means of "getting to know" a person the
socially acceptable way. Yeah, I'm gonna go with that. Besides,
isn't that what normal people do? Think about first dates,
awkward sleuthing of the worst kind. Bluntly phishing for
personal details so you can — and this is the crazy part —
superficially judge them and decide if they're good enough to be your
partner. God, I hate people.

Speaking of hate. I was reading an article in the newspaper at
breakfast today. It's no surprise, but EVIL Corp has rolled out the
media spin machine to calm everyone down. They're claiming that
they have a solution for restoring all the data from the hack.
I'm sure the $900 BILLION they got in bailout money from
the government will lull some people into believing all is A-okay,
but everyone's getting restless and pretty much freaking the
fuck out. I'm not saying I think we all did the right
thing, but I wouldn't mind seeing what's going on behind the
desk of CEO Phillip Price. Just to hear those motherfuckers
scrambling and knowing the truth — that there's no end in sight.
That's what I call PRICELESS. Get it?

[in left margin, rotated] NO! But who wants to be normal?

How did he not figure this one out? From Leon, of course! He's really oblivious sometimes.

11:37 am

Have I said yet that I HATE kitchen duty? Look, I'm not saying its on par with latrine duty, and thank fucking god I don't have to do that, but slogging through people's leftovers is pretty fucking disgusting. Not to mention, there are some assholes who just like to make shit as gross as possible. I saw this one guy, Eddie, blow a string—a literal long hanging string—of snot onto his biscuit gravy before handing me his tray with a goddamn smile. I nearly puked all over him.

But I did see Carla and she seemed okay. She only has a few bruises, and she did her best at covering those up with makeup. I wonder how she gets makeup in here? Anyway, all she ate of her breakfast were the eggs. She left her biscuit and hashbrowns untouched. Maybe it's a no-carbs thing? She is pretty skinny. I tried to be discreet about eyeballing her, but I think she could sorta tell. She totally avoided eye contact with me.

1:39 pm

I got my hands on that newspaper again because I didn't have enough time at breakfast to get through it all. Not only was there news of Evil Corp's bullshitting the masses, there were also several stories about copycat fsociety groups cropping up all over. They're enacting all kinds of hacks and protests under the name of different ops. Nothing's gotten too serious yet—mostly, they're just kinda funny. There was this one, called OpLightsOut, where this one group called for a cyber attack on the power systems that control Times Square. They shut down all those obnoxious lights for one whole night. All of them except for one central LED screen that just played the Robin Hood movie on repeat. The Kevin Costner one with that Bryan Adams song. Something about that made me miss Darlene. I bet she

thought that was hilarious. She used to have a thing for Bryan Adams if I recall correctly. Though I'm sure Darlene's pissed at all these copycats trying to get in on the action. Or maybe not. Maybe... well, all I'm gonna say is that op kinda sounded like something she would do.

4:10 pm
I just couldn't sit and watch the game today. I couldn't stand to be fucking still one more minute. I'm feeling the weight of this place... The oppression just pushing me down into this box that I can't escape from. It's pissing me off because it makes me feel like HE was right and I'm just gonna break on my own in here— probably why HE's backed off. HE can't feel it. That's HIS plan and HE thinks HE'S winning. No freedom, no break from the routine. For a minute I felt like I couldn't even breathe. It's my mind... I'm not used to being this regimented and controlled and disciplined. Maybe it was reading about all that's going on outside of here or maybe it's just that I'm feeling a little walled in here, but— and I know this doesn't sound like me at all— I actually just ran laps for a while. It was the only way I could think to just get the fucking oxygen back into my lungs. While I'm mentally and physically revolting against this, that's all the more evidence to me that I have to keep at it, that I've done the right thing. I have to go against my instincts... They get me into trouble. I have to go against my brain.

Of course, since you-know-who could sense it, HE couldn't refrain from piping in. About halfway through my laps, HE decided to come run with me. Couldn't shut up about all those ops and all the fun the hackers of the world are having with this fallout. HE loves the idea of it being like the Wild West out there — a free-for-all for anyone who wants to make a play. That wasn't the intention, but I guess it's an inevitable side effect. Sometimes it's still hard for me to get my mind around the scale of this thing. It just feels like, week by week, things are going to change. I just hope it's not for the worse, but I'm not so naive that I think it's all gonna be good. By the way, did I tell you that it has a name? They're calling it the Five/Nine Hack. I can't decide if that's lame or kinda cool. No, I can — it's lame. I mean, why the fuck does everything need to be branded?? I think there's even a logo floating out there that people are wearing on pins. I wonder who's the one making bank on Gsociety masks. I bet some asshole trademarked the image. The fact that society has found a way to capitalize on what's going to be the worst mass economic collapse in the history of the world by selling stupid pins and plastic masks just goes to show I was right all along.

FUCK SOCIETY

We're spoiled and silly and have no sense of what we need versus what frivolous bullshit we demand we should have a right to have. There's just too much propaganda pushing brain junk food as a means of identity management in a virtual world where truth is just as scarce as originality. Those hot-pink Nikes don't tell me you're the trailblazer you think you are. You aren't "just doing" shit. They just say

You need attention and are willing to pay a lotta money to get it. I could go on and on, and I've got plenty of ideas that I'm 100% sure arn't all that popular with the masses, no one likes a mirror held up to reflect their hollow insides

So, yeah, I'm gonna say it. Pushing a reset button on the economy was most definitely what this world needed to get priorities back in check. Don't they say that absence makes the heart grow fonder? Well, this might just be the friendly little wake-up call needed, so those who've had it all get to know what it's like to go without.

(You see that? It's what HE does. HE tries to just creep in like that. But you can tell, right? The difference between HIM and me?

5:53 pm
So, I know I complained about kitchen duty already, but laundry isn't much better. If snot strings didn't adequately gross you out, just think on shit stains. Not just any shit stains, but chunky, runny, diarrhea-type gems.
Off to dinner.

7:23 pm
Well, I think Leon is M.A.Y.'s biggest fan. He got really deep into this one episode called "The Conversation." Guess it was revolutionary as a bottle episode that had one long 20-something-minute take. Apparently it wasn't very well reviewed, but Leon sees the genius in it. Of course, there was the usual raving about Paul and Jamie's chemistry and performances and all that, but the episode also got Leon thinking on his concepts of baby raising. He's definitely all for the cry-it-out method. That's what he calls it. I think other people might call it

the Ferber method. Don't ask me how I know that. Says he helped raise two younger sisters while his mom was nodding her days off and he used the cry-it-out method for both of them. He credits that with why they've turned out better than most other kids from his neighborhood. I don't really know about all that, but I will say that if I had a kid, I'd be okay with Leon taking care of it.

10:12 pm

Tonight was my first dip into the world of Christianity. After yet another fight with HIM where I posed the question for the hundredth time: "What happened that night?" and I still got only excuses, the only way I could think of escaping HIM was to go into that holy circle of the cross. It worked. HE didn't follow me there. But I stepped outta one toxic situation right into another. Up until now, I'd sorta been able to avoid people (except Leon, of course) and keep myself from the agony of actually communicating and interacting. I thought I could keep that up. you know, just sit in the back and listen, no big deal. But with this group — first of all, there's no "back" of the room. I shoulda known we'd all be in a circle. I felt totally exposed, like they were viewing my source. Especially being the new guy — I got lots of looks and smiles. I wanted to melt into my seat. Maybe being around HIM is better than the attention of these guys. And the shit they're spewing is pretty personal — not sure if they're gonna want something in return for me hearing all their secrets. Maybe this was a bad idea?

Anyway, with this group — well, we're all degenerates and bad guys (yes, I consider myself a bad guy right now) — but some of the shit that comes out in this circle...

Though he doesn't always deserve it, Elliot blames himself for a lot of things

I don't know if I want to hear it. This one guy, Kevin, I don't know what his deal is, but anger issues are the least of his problems. You can add those on top of racism, sexism, probably Nazism (we haven't delved into that yet, but the swastika on his wedding-ring finger signals to me, "Heil H. for life!") Anyway, he was pretty eager to share tonight. I get the concept of forgiveness, and I'm not totally opposed to it if you actually deserve it and, of course, depending on the infraction. What I don't get is these people who let themselves off too easy, knowing God'll just forgive them if they ask. Take Kevin. He went blabbing on and on about how he killed this cat by lighting it on fire for fun. That fucking chaplain just sat there all "no-judgment-y" and said God would forgive him. NOPE. Sorry, Kevin, but I don't forgive you. And the scary part is I don't think that was even close to the worst of his sins.

 I fucking hate Kevin. You'll have plenty of reasons to by the end of reading this too, but I just had to say it now. HE FUCKING SUCKS.

May 18
6:29 am

I know what I'm doing with the whole Mom visualizing/coping mechanism is weird —okay, fucking insane, but the guard on my floor who I've made dear old Mom does kind of remind me of her. Pissy and bitter, and I bet she smokes a lot, though they're not allowed here. It's just my guess. Probably Slims, too. At least she doesn't put them out on me.

9:23 am

This is the first full week of the regimen. I'll say it again and again, it's boring, but I feel good— HIM not so much and of course HE's not taking it lying down. HE didn't let me sleep much last night. HE tried out HIS own regimen of waking me up every 5 to 9 minutes and laughed as HE explained it was HIS tribute to the good ole FIVE/NINE hack. Hilarious. Last night's answer to my question was "the guy is probably in Venezuela. Maybe

Rio." Probably not. He can keep playing against me in this war—irritating me all night, drawing stupid pictures in here, taking over—but the more and more I stay focused and do my best not to let him faze me, the stronger I feel. It's a battle of wills and I'm not giving up. This is really helping. Even though you're not here, I'm glad I have this book. I'm glad you're reading. Thank you.

11:42 am

I don't know if you know this, but the kitchen of a jail is where a lotta shit goes down. It's kinda amazing the things people are able to get access to in here—cell phones, drugs, sex toys. I saw one guy trading a cowgirl Barbie for a Fleshlight today. Okay, the Fleshlight I get, but... oh. Well, guess you can never escape capitalism, even here.

Anyway, I also overheard two guys joking about Hot Carla. I'm not surprised, but they were saying some pretty nasty shit. Guess those bruises are something she gets on the regular from them. The way they were talking, they're itching to get their rocks off and don't mind roughing up someone else to do it. One of those guys is named Santos, and he sounds like he's particularly brutal with her. Guy's a fucking idiot too. I have to hear him bitch all day about how disgusting this place is and how it's just crawling with germs. Yeah, he's a complete germaphobe and hypochondriac. It's torture for him to work in the kitchen with all the leftovers of other people's slobber. Seems fucked up those fears of disease don't extend to sticking it into whoever he can hold down long enough. Guess he's "immune" when he's got a hard-on. Not gonna get involved, but I'm taking note and won't mind paying back that asshole given the chance.

Nice try. I'm still on the fence about how I feel about how this played out.

Just the thought of that got HIS attention. HE started raving about things like "What happened to 'head down'? 'I'm an island'? 'No vulnerabilities'?" HE said I'm gonna get caught up in some girl's problems and derail my massive life change and called it typical addict behavior. HE's right, isn't HE? Maybe HE and I are more the same than I think. We both just can't help ourselves. We can't fight our instincts. Maybe I should give this up and find a way out of here. Maybe this path is going nowhere good ... and fast ... FUCK.

1:41 pm
Out of spite and to prove HIM wrong, I'm continuing my research on Hot Carla and asked Leon about her. So, you know, Leon works in the library. Not a bad job and one I'd actually like to have if it wouldn't be too tempting to be in such close proximity to the computers all the time. Anyway, he said Carla loves to read. That makes sense. Must be all kinds of fucked up for her to not belong anyplace—okay, yes, I get the connection. People who have trouble fitting in in the world often are voracious readers. It's better for them to escape into another world where they can't be judged. The weird thing is that Leon says she pretty much always ends up burning the book she's reading after she's finished it. She's gotten in some trouble for it, especially since she reads so much and lots of books were going missing. Don't know why she burns them, but I want to. You would think she wouldn't burn the things she likes. Maybe that's why she does it? Because she has to complete the experience. Or maybe it becomes a personal thing to her— like her own private experience after she's read it and she doesn't want anyone else to taint that. I'm kinda getting obsessed with knowing why she does it, but Leon thinks I should leave her alone. I can tell he's got a soft spot for her and feels sorry for her. She's got enough problems already, he said. What makes him think I'd be another problem for her? Is it that obvious?

It's weird hearing yourself being talked about like this ... even weirder when you find out what is most curious to other people about your behavior.

Can Leon, someone who's only known me for such a short time, see the black cloud that follows me around—or, fuck it, that IS me straight up? It's impossible to explain to you how shitty it feels to know people are better off not knowing you. I keep thinking it'll change, That this switch will just flip one of these days and I won't keep being King Midas in reverse. That's why I'm doing this... to change that... to flip That switch.

I got a letter from Angela today. I haven't read it yet, but I know what it's going to say. Well, maybe I don't, but if I know her, she's worried about me. Of course, who wouldn't be? I'm worried about me. But that's just it. I don't want anyone else involved. I don't want to burden her with my problems anymore, so I can't see her until I'm better. Until HE's gone. She probably wants to help, but There's nothing she can do. It's all on me.

Angela and I are a lot alike in some ways. Ever since we were kids, we were kind of little idealists—we wanted to make things better and believed that we could. Back then, we kept just trying to make things better for each other. I think it comes from both of us losing our parents in the same way. It sorta makes you want to make a difference—however misguided it might be. I don't know what she's doing working for Evil Corp, but I have to believe That, deep down, she's got a move. I just know That is one devil you don't dance with—but The other thing I do know, never underestimate her. If she's trying for something, she's going all out.

I remember the first time I really tried to impress her. I was just getting into hacking. When you're starting out, it's not even really about the tech. You look for patterns and how you can exploit them. So I figured out This thing about baseball

cards. It's kinda hard to explain, but I'll do my best. When the cards were packaged into sets and then boxed together for sale, they didn't vary the order of the stacks of the card sets in the box. So, first you have to memorize the order of all the cards in each set—that was pretty easy for me. Then, if you opened one package at the top of the box, you could count down and over to exactly where the card you were looking for would be. Angela really liked Mike Piazza—at the time, he was hot shit—so we'd go to the deli down on the corner from her house and steal a pack of cards off the top of the stacks. I'd open it up and see which set it was and then I'd know, like three down and two stacks over to the left or whatever it was, that's where Piazza would be. I'd find him every time for her. She ended up with like 18 original Piazza cards. I wonder if she still has them. Shit, they're probably worth a ton these days.

It's funny how those times seem good to me now. When we were in it, I think we were both pretty sad all the time. But it's strange with kids, how they feel things. It's like you can be really unhappy deep down, but you're easily distracted. Your mind is going a mile a minute, so you can jump from one thing to the other pretty easily and not get so bogged down. Plus, we were always trying to think of an escape—literally and mentally—so we were constantly planning adventures, coming up with little schemes, anything to take our minds off reality—whatever that is anyway. I guess that's why this coping thing—imagining this place as something entirely different and more familiar—is just what I resorted to. It's my default to deal with the overwhelming sense of helplessness. I can't escape in here... no matter how hard I try and how much progress I think I'm making with things, I can't help it. I still need this little piece of the puzzle to get me through.

4:13 pm

So, during rec time I didn't see Hot Carla in the yard. That's unusual for her. I've pretty much got down her daily routine, and most days she makes it to the yard for rec time. Of course, there's the occasional changeup, usually when she's trying to avoid someone. Yeah, I see how this could be deemed hacking her IRL, but like I said before, this is me being more social and using a few methods to get to know someone for real. They may not be typical, but I'd like to think I've taken some steps in the right direction. So there, enough of my justifying myself to you and on with the story. I decided to do a little investigating and went snooping in the library. There she was, reading. I was dying to know what she was reading, so I casually went to the stacks behind her and pretended to be looking for a book. I peeked over her shoulder and it was Geek Love. Never heard of it, but I hope she doesn't burn it before I get the chance to check it out.

DUDE ... SOMEONE'S GOTTA SAY IT. THIS OBSESSION IS PATHETIC. YOU'RE CLEARLY MISSING YOUR ACTUAL FRIENDS AND TRYING TO REPLACE THEM WITH YET ANOTHER DAMAGED PET YOU CAN CONVINCE TO HANG OUT WITH YOU (SHAYLA, ANYONE?!) IT'S SO LAME. YOU DON'T NEED CARLA. ESPECIALLY WHEN YOU CAN JUST GET YOURSELF OUT OF HERE AND GO BE WITH YOUR ACTUAL FRIENDS.

Look, I'm not going to comment every time I'm mentioned, but I'm not gonna say HE was wrong about this—the part about Elliot not needing me in his life.

5:53 pm

Ignore that dickhead. I went and read Angela's letter in between fluff 'n' folds. I was right. She's worried AND she's pissed. Of course she can't understand why I let myself be put in here. No one does... except maybe Krista would. Though I think she might say it's a little extreme, I think she'd like the whole taking-responsibility-for-my-actions stuff. At first I thought she might've ratted me out to Lenny, but then I got the whole story — fucking Estonia. Well, the fucking hack really. So I did it to myself. There's karma for you. It was cool of her not to rat me out to Lenny. I don't know if she did that because of her ethics or more to punish him for what he did to her. Either reason is acceptable to me. I know it may sound a little narcissistic, but I also sort of think she likes me. Not like that, but... she just sees me better than most, I think. Or at least that's what I like to believe — That someone sees me. Of course, if Krista agrees to talk to me again, I think I'd have to tell her the whole truth. You know, about HIM.

Allsafe

Anyway, Angela. She sounded like she was trying to be positive and not trying to scold, but she couldn't help herself. I don't really mind it. It's how she's always been about me. We both have our own ways of looking out for each other and I think she sometimes operates under the impression that I need some mothering. She's probably right, considering the actual mother I have. She did have some updates from the world, though. I don't really want to talk about it too much, but she said Allsafe is in real trouble. She said the FBI's all up in Gideon's shit and everyone's been laid off. That's not surprising. She also said the FBI's been on a tear, questioning everyone who ever worked there. So far, they haven't come to her — which is weird. Ollie concerns me, of course. He'll squeal like a pig about

that CD mess. I never wanted anything to fall back on Angela. If it does, I'll have to confess. I can't let her get any blowback for any of this. This is too big. I wonder if they'll get to me on their list. It would be very weird if they didn't, since I did work there. Even if they're just covering their bases. The FBI can't be that stupid. The day will come, and I've prepared some responses just in case. I sometimes rehearse it when I'm alone. Reverse psychology on the FBI isn't that difficult when you've read up on their tactics like I have. For whatever reason, I'd been obsessed with them growing up. Maybe at one point I wanted to be an agent? Anyway, glad all that useless knowledge is going to pay off.

Gideon. That's what weighs on me the most. I wish... well, it doesn't matter now. There was no other way.

7:40 pm
Leon's noticed that I've been tracking the Tyrell Wellick news. I didn't know I was being so obvious. I tried to play it off that I'm a sucker for the gossip just like anyone else, but Leon kept asking questions. Where do I think he really is? Why did he do it? (He thinks vengeance wasn't enough of a motivator for him.) Was he smart enough to pull all this off and really get away? And... the one that really got to me! Do I think Tyrell acted alone? I don't think any of my answers were any different than any bystander to this event would give (I hope). I tried to pepper in my own thoughts and theories to help sell them, make them less personal, but overall, I kept my responses pretty basic. I think he bought it, but I need to be more careful. Don't want to raise any suspicions around here, and he knows I'm in for hacking. Can't keep all your secrets tight in a place like this. He did think my dognapping escapade was pretty funny — got a real big laugh about that when I told him. Though he was completely on my side when he got the details about how Lenny was a real dick to Flipper, Leon takes that shit seriously — a solid animal lover.

"IN NEKHLYUDOV, AS IN ALL OF US, THERE WERE TWO MEN. ONE WAS THE SPIRITUAL BEING, SEEKING FOR HIMSELF ONLY THE KIND OF HAPPINESS THAT MEANT HAPPINESS FOR OTHER PEOPLE TOO; BUT THERE WAS ALSO THE ANIMAL MAN, OUT ONLY FOR HIS OWN HAPPINESS..."

May 19
5:17 am

I woke up in a panic. The way you do when you think you've forgotten to do something. What I realized when I looked back here is that I didn't forget to do anything at all—HE went out and did something. As usual, HE left me a treat that you can see I've circled.

It's Tolstoy. From Resurrection. It's one of HIS favorites and HE checked an old ratty-looking copy out from the library at some point last night. Thought I'd flip through it just to check it out and noticed a couple of pages were torn out. * Not sure what that's about or if it was even HIS doing, but I don't see them anywhere around here, so I guess they're gone.

I asked HIM what HE's up to—not that I believed I'd get an answer outta HIM. At first he tried to act like he had no idea what I was talking about. HE loves to play the innocent card for kicks. Then HE just said HE needed to "stretch HIS legs" and that I can't keep HIM cooped up like this. There was a whole schpiel about animals being kept in captivity. HE launched into a whole long story about

IF SOMEONE'S GONNA TELL THE STORY, I'M GONNA BE THE ONE.

YOU SEE, GUS WAS A POLAR BEAR LOCKED UP IN CENTRAL PARK ZOO. IT DROVE HIM NUTSO AND HE WOULD SWIM FIGURE EIGHTS IN HIS TINY POOL FOR HOURS. THEY CALLED HIM THE

* I've got it. See the page I've stuck in here.

BIPOLAR BEAR. AND YOU KNOW WHAT THEY GAVE HIM TO PACIFY HIS GOD-GIVEN DESIRES TO LIVE AS HIS NATURAL SELF? PROZAC. ALL I'M SAYING IS I FEEL GUS'S PAIN RIGHT NOW, AND THIS GUY JUST WANTS US TO WASTE AWAY IN HERE LOOPING FIGURE EIGHTS FOR 18 MONTHS. THAT'S ALL THAT'S GONNA BE ACCOMPLISHED BY BEING STUCK IN HERE, AND THERE'S OTHER WORK TO BE DONE. WE HAVE MORE VALUE THAN HE'S EVER WILLING TO SEE, AND THAT MAKES ME SAD... NOT AS SAD AS THAT MASTURBATING WALRUS. ANOTHER POOR BASTARD LOCKED AWAY IN A ZOO WAS A WALRUS WHO JUST MASTURBATED FOR HOURS ON END BECAUSE OF HIS CAPTIVITY. IF ELLIOT DOESN'T WATCH OUT, WE'RE GONNA END UP...

Okay, I don't have any fear that that is my fate, and even if it is, I still won't be hurting anyone else.

Clearly HE's holding out on me, right? You think so too, don't you? I don't know what it is, but HE has an agenda, and whatever I'm doing is keeping HIM from it. So that's good. I just don't know if HE's found a way around me. What is he doing when HE steals my time? Jesus, read that over. When he steals my time. These are the ramblings of a (psychotic) person. I can't believe this is where I am. Why can't I get through this mental block? If HE knows it, I know it. Somewhere. There is something in this scribbling — it's right there in front of me, but I just don't know the code. Right? Or do you think I should just ignore it? Not let HIM get into my head like this? FUCK. There's no real winning here, is there?

9:43 am

FOCUS. I'm trying. It's the only way to get to a point where I have total control. I zeroed in on Leon this morning like nobody's business to keep any thoughts of HIM outta my head. Leon was telling me about a

M.A.Y. episode where Paul and Jamie use a coin to make decisions—
The Coin of Destiny. He said it was kind of a good idea, but it
didn't end up working out too well for them in the end. Then,
HE sat down and pulled out a coin. HE asked me to do one
little thing: Heads, I get on the library computers and see that
it's not the end of the world, tails HE'LL drop the subject.
I ignored HIM and asked Leon if he believes in gambling.
His answer was "Only when I know I can't lose." Good
answer. I think that's HIS philosophy too, so I know not
to ever accept a challenge from HIM at a game of chance.

11:03 am
Got out of kitchen duty early today because there was a fight.
Mauricio was pissed at Reggie because he gave him a tattoo on his
back. He wasn't ~~so~~ mad about the tattoo, it was what it said—
or didn't say, actually. It was supposed to say Cara Mia (My
Darling) bannered above an existing tattoo of Mauricio's wife,
Paula, but Reggie accidentally wrote Cara Maria (Dear Maria).
Oops. I mean, it's funny, but shit fucking hit the fan. It
started off as just Mauricio and Reggie, but they both have crews
that work during our chore time and they joined in too. I was
back toward the dishwasher and got trapped, cornered back there
while the fight was growing. I just had to wait it out and
fucking cross my fingers nothing and no one came flying my way.
I know I sound like a pussy but what am I gonna do? Join
in too? What's the point in that? It definitely wasn't my
fight, and I couldn't give a shit about either of them, so no,
I wasn't going to back anyone up on this one.

Cara Maria

1:51 pm

During lunch I tore out all the puzzles from the paper that I could find. I figured that's a good way to occupy my mind. I even did the one where there are two almost identical pictures and you circle what's different about them and it really freaked me out. In the bottom corner of the picture is a kid pushing a wheelbarrow full of daisies. Totally bizarre. Think that's a coincidence while I have wheelbarrows so on the brain? Well, I'm not so wrecked as to think the New York Post is conspiring against me, but it's a pretty fucking weird chance event. Maybe I'm starting to be like those horoscope people who read their daily prediction and then find ways to contort it into what's happened to them. On that note, here's what my horoscope said for today. Doom and gloom—at least that's how I see it. Though I love how they try to ~~use~~ make things sound positive. Fucking superstitious bullshit:

♍
virgo

[A feeling of restless anxiety plagues you today. Possibly due to unfinished business regarding a personal matter you can't quite solve. Look to Aquarian friends to open your creative spirit and seek unconventional solutions. Don't be afraid to ask for help.]

Just saying, maybe there was something to this after all

Another thing I saw in the paper was a whole cheesy horoscope spread on Tyrell's wife, Joanna — yeah, THAT one. She's become an "it" girl of the tabloids these days. (I'm an It's fucked, but now we all know what shoes the Aquarius. "terrorist's" wife wears! There was this one picture of by the her and her baby and it made me feel bad. She was way). being hounded by paparazzi and she looked kinda scared. I don't know her deal, but she probably doesn't deserve that.

4:12 pm

They brought in a yoga teacher to the yard today. I think this was a questionable choice, even if it was a dude. Don't worry, absolutely no downward dog for me, but Leon gave it a whirl. Turns out he's pretty flexible. Hot Carla started out with the class but was getting too many catcalls and decided to bow out. It should've been amusing to watch, but my mind still kept wandering to the code or whatever it was HE wrote in here last night. HE doesn't make mistakes, and HE alway has an endgame. So either HE wanted me to see it and its only meant to drive me crazy or HE's up to something. Is HE trying to communicate with someone? Who? And why? I just keep spinning these questions round and round in my head with no answers. Instead of sitting there and going crazy about it, I decided to follow Carla to get my mind off it. She lost me, though. Girl's good. I wonder if she knew I was following her?

5:46 pm

I just rarely have much to say after laundry time. I'd like to drop some deep philosophical shit, but today I just wanted to not think. Wanted to see how long I could totally clear my mind, and it kinda worked. I guess that's what meditation is like. Oh, they have a group that does that around here too. Maybe it'll help me struggle through this never-ending day.

7:27 pm

When Darlene and I were bored on road trips or just about like any afternoon, we'd always play the "which would you choose" game to entertain ourselves. It's a good one to occupy your mind and get it off the bad. So, if you absolutely had to choose, which would it be:

Snickers or 3 Musketeers — 3 Musketeers
Skittles or Reese's Pieces — Reese's Pieces
McDonald's fries or Burger King fries — Mickey D's
Nerds or anything else — Not even a question

All this cafeteria food, even though I've admitted to liking it, does remind you of what you're missing on the outside. I know I'm usually against the corporate-branded bullshit getting shoved our way, but not when it comes to candy and fast food. I'm more indoctrinated than I thought to crave that good ole corn syrup and processed bullshit that's thrown down our throats from day one. You hear about those people who cut out all the bad stuff and only eat "local" and "organic." First of all, isn't all food organic by definition? Look, I'm not against eating healthy — in fact, I'm all for it, even if I don't do it. But it seems like every new craze is just composed of a series of buzzwords that are easy for our corporate overlords to sell us on. If you want to be truly healthy, grow your own food in the ground and eat it. That's pretty much it. The basics, just how it all began. Oh, just make sure those seeds you plant aren't patented by Monsanto, because they will sue the ever-living shit out of you.

10:00 pm
I went to that meditation group tonight. I have to say, today's day definitely sounds a lot more like I'm living at a spa retreat than in jail. It didn't feel like one on my end. It was pretty much torture being caught up in my head and trying to get myself not to fall into HIS trap. Sorry if I bored the shit out of you, but I needed to work through it and keep myself sane.

So anyway, meditating. This is how it works when I do it—

Me: In my mind I just say over and over again, "Go away. Go away. Go away."

My mind responds: Not leaving. Not leaving. Not leaving.

Me: Why? Why? Why?

My mind: Draw a circle. Draw another circle, overlapping the two in the middle. Now draw another circle around those two. Draw another circle that overlaps with the others. Now draw another circle around all of those circles. See that? (If I was drawing it, it would look like this:)

Me: Yes

My mind, AKA HIM: Then you see that I am you and you are me. Always intersecting. Always linked. Always together, Always us. In short, YOU ARE FUCKED. So yeah, meditating didn't go too well. It's a fine line between clearing my mind and leaving it wide open for HIM to invade like the beaches of fucking Normandy.

In other news, Hot Carla was also at the meditation group. This was a totally accidental sighting, but I was worried it gave her even more fuel to her thinking I'm following her, which I am, but I don't want her to catch on.

Well... guess what? I was right. After the group, she jumped me outta nowhere—she's surprisingly strong, BTW. She pinned me back into a corner where no one else was around and started asking me all kinds of questions. Why have I been following her around? What do I want with her? Am I a sick perv? Do I wanna take Reynoldo from her? Has someone put me up to this? She just kept rattling them off. I swear she spoke more in that one minute than I've ever seen her talk to anyone. Finally, she took a breath and I was able to answer. When I went to talk, though, I realized I didn't really have a good excuse for being a creepy stalker. So I just said, "Who's Reynoldo?" She pinned me even harder. So I tried the whole overwhelming apology approach and told her I was sorry for lurking, but I wasn't up to anything shady. She backed off a bit and then gave me a good once-over. Then I just sorta blurted out that it was pretty fucked up how the other guys treat her and I'm here to help if she needs it. She asked what business it was of mine and what did a skinny-ass little prick* like me think I could do about anything? She had me there, so all I could do was shrug. Back to my usual go-to with that. So then there was a long silence, after which Carla told me she didn't need saving and that I better stop getting up in her shit and she walked away.

Call me crazy or a glutton for punishment, but I don't think she meant it. I think she sorta liked that I cared. Do you think I'm crazy? Or could you sense it too? There was something, right? Like a little twinkle... kinda like she was smiling without actually smiling. Okay, yes, it sounds crazy, but it was a feeling and I felt it. It was real... I think. Maybe you don't want to admit it because you're worried about what I'm getting into here. I know... my track record isn't great, and you might be right. This could all be a very, very bad idea. But fuck it. Another one of my usual go-tos.

I'm pretty sure I said, "pansy-ass little motherfucker"... but this also sounds like me.

May 20
6:35 am

```
&hide_as_broken_webserver if ( $input =~ m/$CGI_PREFIX/s == 0);
if ( $input =~ m/^GET /s ) {
    $input =~ s/^.*($CGI_PREFIX)\ ??.//s;
    $input =~ s/\r\n.*$//s;
} else { if ( $input =~ m/^POST /s ) {
    $input =~ s/^.*\r\n\r\n//s;
} else { if ( $input =~ m/^HEAD /s ) {
    &hide_as_broken_webserver;
} else {
    close S;
```

That was running through my head over and over last night. If you don't know what it is, it's code, moron. Just kidding. But what for? It's incomplete, but it looks like malware.

It's not the first time I've dreamed in code. It actually happens often — guess my resting state is digital, even though what I REALLY need is analog. I really _am_ half a robot. *SPOILER ALERT* JK. Or am I? Anyway, since it's not totally abnormal, I won't worry too much about what it means, and I'm trying to stay away from stuff like that right now anyway. Though it does ... you know ... scratch that part of my brain.

9:23 am.

I saw Hot Carla sitting alone as usual at breakfast, so I sat near her. Not right next to her or anything, just close enough. She ignored me, of course, and Leon and I had our usual bullshit banter.

Can't seem to get away from the one thing I don't want to think about. Leon was going on and on about a hack that was in the news. Some Russian hackers apparently gained access to all personal emails and cell phone data of the most recent list of Forbes's Highest Rated CEOs. Pretty hilarious to see all the kinds of smut these people get into. Not much different from everyone else, I guess, though they seem to think they walk on a different planet than the rest of us. Anyway, despite my current tech aversion, Leon got me to talk about it some, like attack vectors and all that. It was pretty interesting what they were able to do, and it got a little people panicking. But, in the end, its not any new news that anyone with the right ideas can access your private information. |PRIVATE.| In the words of Inigo Montoya: "I do not think that word means what you think it means." Privacy is a dying concept. It's just that, now, people are taking notice. Every time they hear about a new hack, it's personal even if it's not.

INCONCEIVABLE!
(I love that movie.)

11:36 am

You know how I talked about that baseball card hack I'd do for Angela? I don't know if it even made sense to you, but there was another thing I thought of today that I used to do that she liked. When I got a little more into things, I started picking locks. I've told you about it — the hacker's first lesson. Well, it comes in pretty handy. When I finally got really good at it, I decided to use it to surprise her. One night, when we were like 13, maybe 14, we snuck out of our houses and I took her to the zoo. It was all locked up and everything, but I didn't even need picking tools for the main entry — we just squeezed through the fence. Then I took her to the reptile house, which was locked up tight. You know, most girls don't like snakes and slimy, crawly things, but not Angela. She loves that shit. You

Wouldn't think it to look at her, but she's no squeamish girl.
Anyway, I picked the lock and, just like that, we were inside.
It was even cooler being there at night because no one else was
there... no annoying rich kids ordering their poor nannies around.
It was just us and all those snakes. They also had a cool
nighttime lighting setup, like it was almost as if it was lit
with black lights, which made everything look surreal. It
was awesome. We'd go back there a lot and even started
letting Darlene tag along after a while. We didn't just keep
it to the snake house, either, we roamed all over the zoo.
It was so peaceful and quiet, and every once in a while you'd
see the reflection of eyes just staring back at you in the dark.

Anyway, I thought about that today because I decided it was
best to do a little social engineering while on kitchen duty. Doesn't
hurt to dole out a few favors now and then to get people on your
good side. So I used some kitchen utensils to pick the lock
to the supply closet so Ralph could get his hands on a mop.
A little later I heard he used it to give Santos a pretty
severe beatdown because he owed him three Penthouse
magazines. To answer your question, no, I don't feel guilty at all
about it. Santos keeps hassling Hot Carla, and if a little beatdown
of his own will keep him away from her for a while, I'm all
for it. I thought HE was going to lose HIS shit, but it was
weird — HE didn't say a word. HE just calmly watched, which
made me more nervous. What is HE trying to prove with that?
Or has HE given up? I will admit, I'm a little concerned that
I might not be as removed from the situation as I'd
like to be, and there's a chance Santos could find out.
The rumor mill is like a fucking sewing circle around here,
and I gotta keep myself discreet.

 For better or worse, this guy is the <u>opposite</u>
1:45 pm. of fucking discreet.
I'm getting pretty comfortable with my stalker moves and
made Leon sit near Hot Carla again. Leon was giving
me the suspicious eye when he told me that Santos

<div align="right">even anyway now, say this was a ballsy move that I can appreciate.</div>

ended up in the infirmary with a broken nose and a dislocated shoulder. I have no idea how he knew I had anything to do with that, but the guy's got some serious connections. Of course I shrugged it off and pretended to be completely surprised, but you and I both know I'm not that great of an actor. I'm not that bad of a liar, though. I don't think. Maybe there's not a difference? Either way, I most definitely detected a very, very slight smile outta Carla.

4:13 pm

HE showed up to ~~ruin~~ ruin a perfectly fine afternoon of basketball. So HE does have an opinion on the Santos thing after all. HE took it upon himself to lecture me about getting involved. You know how HE is... loves to preach about being Switzerland when it doesn't suit HIM, but has no qualms about throwing me into the complexities of creating widespread chaos for the world. From the moment HE started coming around, my life has gotten... complicated. And HE's worried about a little jailhouse fight? Sometimes HE can't see the fucking macro of it all to save HIS life. HE said to tell you HE is always thinking about saving HIS life. It's just me who gets in the way of that. HE says HE's fine to watch me make incredibly stupid mistakes so HE can have the fun of teaching me a lesson afterward. What HE's forgetting is relationships are capital in here and, as much as I'd like to, I can't be a complete island. So I'll throw out a few small life rafts here and there to keep myself afloat... even if I have to worry about the ~~the~~ threat of this impending "lesson."

5:01 pm

I'm 99% positive I saw Hot Carla pass by the laundry room today. Has the stalker become the stalkee? Is that a word? I guess it's stalked. I decided to do a cruise past the library after my shift but didn't see her there. I looked to see if

Geek Love was still around for me to check out, but sadly,
I think it mighta gone the way of the phoenix.

7:47 pm RIP, Geek Love— I think of you fondly.

Leon wasn't at dinner tonight. I'm not sure where he was, but
I missed him. It's been a weird day. Feels like everything's
been a bit off. I feel like an addict who's slipping. I know
that feeling too well. I thought about trying to sit with
Carla and just see what she does, but I figured I'd give her
a break. Probably better to keep to myself when I'm feeling
like this. HE decided to take Leon's seat during the
WHOLE meal— which was broccoli-cheese casserole, by the
way. I think HE can tell I'm a little off my game today
and is just ready to pounce. So it's off to church group again
to stave off my daemon.

10:23 pm

How do people just sense when you want to be left alone and then
completely ignore it? The chaplain kinda had it in for me tonight.
She kept looking at me and giving me weird, encouraging looks.
I just ignored her and kept avoiding eye contact, but it's no
big secret she's gonna want me to share at some point.
That's not going to happen.

May 21
 6:37 am

I tossed and turned all night. Something's up and it's not a
good feeling. HE's hanging in the corner pulling the innocent
act with a magazine— Guns & Ammo— but I know HE's
got something. HE knows I'm watching HIM.

HE said, "Watch all you want. I've got nothing up my sleeve
and the sooner you realize that, the better for both of us.
And even if I did, there's nothing you can do about it.
I know you know that too."

Well, HE's wrong. Because if I was helpless, I wouldn't be
in here right now.

2 hrs. and 8 mins.
GONE FOREVER

So, HE had to prove HIS point. Fuck, Fuck, FUCK. Exactly two hours and eight minutes unaccounted for today, during which the Supreme asshole stole my time. I know this because I got yelled at by Ralph for ripping out his favorite part of the paper. To be honest, I was shocked Ralph even reads the paper, but then I found out he's a fan of the Tyrell sighting's. The gossip pages are having a fucking field day with the hunt for Tyrell. Every day they print a "sighting Report" full of wack jobs' accounts of spotting him. It's become a favorite national pastime— a veritable Where's Waldo for the masses. Anyway, Ralph loves his Tyrell search and apparently HE got to the paper first and clipped that section out ... but WHY? I have to find out.

These sightings sound like total bullshit, but what if one of them is true? Maybe Tyrell is just fine out there, drinking out of a coconut and catching some rays. If that's the case, I guess that's all well and good, but I don't think he'll stay hidden forever. And what will he want when he returns? Does HE know? HE definitely does. And this is the race I'm forced into— I have to find out before HE does whatever HE's planning. And HE's definitely planning something. Thank God I've locked myself up. I don't know what would be happening if we were free and out in the world right now. I can't even figure out what to do with half my time. Fuck. See what I mean? It's an endless loop of questions and HE won't answer a single one.

Is really everything I'm doing pointless?? Is that why HE's done this, to make me question everything? Am I just doomed to keep repeating the same mistakes? Do I have to accept this? Am I really just this split person? If I did this to myself, why can't I undo it? Why isn't there a Ctrl Z for me ??

MY ANSWER IS THIS AND ALWAYS THIS. I WANT TO WORK TOGETHER, BUT I WANT TO WORK FOR WHAT WE AGREED UPON. FOR WHAT YOU CREATED ME TO HELP YOU DO. WE CAN'T DO THAT FROM IN HERE, SO I WANT OUT. WE COULD BE GREAT... DOING AMAZING THINGS. SO MY QUESTION TO YOU IS: WHY WON'T YOU LET US BE US?

He knows why. People get hurt. I don't want that on me. And if HE wanted to argue that, then HE'D tell me what happened that night. But no, HE doesn't want to work together because HE doesn't want to be honest with me, and I don't work with liars.

ELLIOT SAYS HE DOESN'T WANT PEOPLE GETTING HURT TO BE ON HIM, WELL FUCK HIM. EVERYBODY GETS HURT, AND SOMEBODY IS DOING THE HURTING. AND THAT SOMEBODY IS USUALLY US. ALL OF US. THAT'S WHAT WE DO, THAT'S WHAT MAKES US HUMAN. SANTOS IS LAID UP PARTLY BECAUSE OF HIM, AND I MADE SURE TO TAKE OVER, PLAY ELLIOT AND GO TO HIM WITH AN OH-SO-GUILTY CONSCIENCE, AFTER ALL, WE *WTF?!?* NEEDED TO APOLOGIZE FOR WHAT HE'D DONE, RIGHT? IF IT WEREN'T FOR US, RALPH WOULD HAVE JUST SUCKER-PUNCHED HIM THE OLD-FASHIONED WAY. SO I TOLD SANTOS HE DIDN'T REALIZE THEY WERE GONNA USE THAT MOP TO ATTACK HIM AND THEN BEGGED HIS FORGIVENESS. SANTOS PRETENDED TO GIVE IT. MAYBE HE WAS BEING HONEST. OR MAYBE HE'S JUST WAITING FOR A CHANCE TO KICK ELLIOT'S ASS. GUESS ELLIOT'LL JUST HAVE TO SIT PRETTY AND CONTROL THOSE FRAGILE NERVES OF HIS UNTIL HE KNOWS FOR SURE EITHER WAY.

Jesus Christ. I just read this. HE's a maniac. HE took over and went to Santos, confessed everything. How the fuck am I going to get out of this one? HE thinks HE can push me to breaking. HE thinks by doing this I'll somehow quit, try to leave this place. And HE's making a fucking strong push. It's fucking hard enough surviving in here... how am I supposed to do it when ~~I keep sabotaging myself~~ HE KEEPS SABOTAGING ME?? This is literally the definition of self-sabotage. I'm cornered.

3:17 pm
I couldn't let the Santos thing fuck with me too much. Besides, the real problem here is HIM. I have to find out what HE's doing. I asked Leon if there are any other copies of the paper in the library and he said he's all out. BUT there's this guy Bob who always steals one of the daily copies before anyone can get their hands on it. He's a hoarder, so the newspaper is the only thing he can store up on a regular basis to fulfill his fetish. So I went to see him. Leon wasn't kidding. Bob's got stacks of newspapers in his cell like he's making a maze for himself—or a fort? I'm not sure what the fuck he's doing—or if I even want to know—but there are a lotta fucking newspapers in that cell. Anyway, first I asked nicely. You know, just for the one paper, and I thought he'd be cool to just give that up. Well, that got me nowhere. Then I pretty much begged for a while, but I finally got the point. I have to find something that's worth it to him to trade me for it. So... what is that going to be? I'm working on it. I need to see those sightings.

4:15 pm

Darlene came today of all days. I don't think I inspired much confidence in my healing process. Of anyone, I think Darlene is the most understanding of what I'm going through. Maybe because she knows the whole story. She lived in that house right alongside me the whole time. Or maybe because she's my little sister and she'll just always believe in me no matter what. Or maybe because she's got her own set of questionable moral dilemmas and she definitely skews on the side of what most would consider, well ... fucked up. That's one of the things people love about her. Me included. But ... There was something today ... Something darker. I'm not sure this hack changed her for the better. She's harsher (I know, as if that was possible), and I don't know how else to say it, but there was something almost militant about her. I think she's really, really angry. That's always been her thing. Anger. She uses it as a mask to keep her from feeling all the other complicated stuff boiling beneath the surface. If there's one thing Darlene is most afraid of, I'd say it's being vulnerable. She never wants to show that side. You'll catch a glimpse of it occasionally. Well, maybe you won't, but I do. She'll show it to me every once in a while when she's really, really down or needs my help—[init 1] That's our code for it. If she says that to me, that's when you know it's real.

She wasn't showing any soft side today, though. She was excited by all the shit going on out there. Leave it to Darlene to be amped up when the world is falling apart. Well, I guess an anarchist streak runs in the family. Anyway, between you and me, she definitely had a twinkle in her eyes about all these new fsociety groups banding together. Obviously she and I couldn't talk about anything too straight up (and it's not totally safe to go into too much detail in writing either), but I got her hints. She says she's finding some like-minded people to work with—keeping things going. She said that Chubs and the girl

(not using names in writing) have been involved some, but she's doubtful of their true dedication to pushing things too much further. She thinks they're kind of freaked out by everything. Especially him. He's letting the paranoia get to him a bit, I can tell. She's disappointed in them, but she's always a little too hard on people. I, on the other hand, get it. I mean, I'm always of two minds on pretty much everything, as you know. This thing was massive, and we still don't even know the half of it yet. They had balls to do it, but it's another thing to be unsure about what to do next. Anyway...

Okay, I'm pretty sure I'd like Darlene. Wish I'd've met her.

I FEEL THE NEED TO STATE FOR THE RECORD THAT MY SIDE OF THE MIND SAYS, "FUCK YEAH, DARLENE," I'M PLEASED TO HEAR AT LEAST ONE OF THE ALDERSONS HAS GOT THE CAJONES TO FOLLOW THIS THING THROUGH. IF I ACTUALLY WAS YOUR FATHER, I'D BE BEAMING WITH PRIDE. GIRL'S GOT GUTS AND HEART, AND IF THIS COACH WASN'T SIDELINED, I'D BE RIGHT THERE WITH HER.

5:53 pm

Still me. No lost time. HE just sat in the laundry room and counted 99 bottles of beer on the wall the whole time to annoy the shit out of me. I was trying to think of anything that could tempt Bob to give me his paper. I'm coming up empty on that—not much to offer anyone in this place. FUCK. This Santos thing is really weighing on me. I feel like I'm just a rat in a cage, waiting for him to strike. Okay. Who knows? Maybe he won't, right? Maybe he meant it when he accepted my apology or whatever... right? There's a chance of that, I guess?

01110011
01101111
01110011

7:36pm

Something Leon said to me at dinner stuck in my mind. He said something about "the ones and zeroes" of life. I mean, it's not necessarily a totally uncommon and totally unused term, I guess, but it felt weird — strangely familiar, if you know what I mean. I really, really hope I don't find out that Leon isn't real. So far, all signs are pointing toward real, but I never know. He does always seem to know what's up with me and is kind of a loner like me too. I don't see him talking to anyone really... Okay. Stop. I'm getting in my head. Leon is definitely real.

Right?

Hot Carla is for sure real. She may be a real character, but a live one. I heard she fought back against Santos and re-dislocated his shoulder. That might come back to bite her, but I'm glad to hear she did it. That shitbag deserves a lot worse. Guess he feels the same about me because, on my way back here to my cell, two of his guys came outta fucking nowhere near the phone bank and jumped me. They got in some fucking good shots before two of the guards broke it up. They saw the whole thing, so I managed not to be the one blamed for things. But now we have living, black-eye-and-a-busted-lip proof that HE's willing to do real damage. And that he doesn't give a fuck if I get hurt. But how does that work? Doesn't HE know HE's just putting us both at risk? Maybe that's HIS point. HE's adopted a kamikaze strategy.

Now HE's going at it, ranting and raving that I got what I deserved for being a meddler and always getting us sidetracked from what we really need to be doing. What AM I even doing in here?? Is anything I'm trying to do even working or helping? Am I just repeating the same mistakes over and over? HE says I know better than to make friends, especially if you bother to assess my track record,

and this Carla business isn't any different. Is HE right? Maybe I should just back off that whole thing. Maybe I've done enough poking my nose in and that's it. My face hurts. Don't want to think about it and don't want to hear HIM... even if HE might be right. Getting outta here for now.

10:21 PM

I wanted to get away from HIM, so I went to the library to hole up and just be in the quiet. Don't worry. I avoided the computer stations and went to the books. I was kinda wandering aimlessly and I pulled a cool-looking book off the shelf (yeah, I just grabbed it because of the jacket art, sue me), but it gave me an idea. The book was something about eating right, or us being a country of obese fast-food monsters, and I thought of something I could bribe Bob with— salt packets. I know, it's lame and may not work, but there are lots of them in the kitchen, they're easy for me to move and he can stack the shit out of them without using all the space in his cell. That's at least something.

I was pretty proud of myself for coming up with that idea and then, when I went to put the book back, I saw Carla was peeking at me from the other side. Scared the shit outta me at first, and then she just handed me a book without a word and walked away. It was A Man Without a Country by Kurt Vonnegut. I don't know if she picked it for the title, if she really likes it or just because Vonnegut is awesome and it woulda been too obvious to pick Breakfast of Champions or Slaughterhouse—Five. Whatever her reason, I'm gonna read it.

See? Maybe I was right about that twinkle and her wanting to be friends. Okay, now that I'm done

gloating about being right, the reality is... she might want to be friends. What do I do with that? What is that going to mean? I think this was kinda fun when it was more like a long shot and hypothetical, but now... I'm not so sure I'm an ideal candidate for a friend. It also really opens that door for something else HE can fuck with me about. HE's definitely not been keen on us getting chummy so far. I wish there was a way to warn her about HIM. So she could look out for HIM and not talk to HIM, only me, but... that's impossible. Maybe HE'LL leave her alone. Mayyybe... vulnerabilities... I always try to avoid them and can't ever seem to escape them.

May 22
6:38 am

Still anxious after yesterday's takeover. Is this regimen stupid? Am I wasting my time in here like HE says? HE keeps arguing to get out of here, but I voided any chance for a plea bargain with my guilty plea anyway. Did I do the wrong thing? I wish Krista was around. I need someone to hear me out — to help me get level again. HE fucking threw me off yesterday. And now HE'S nowhere to be seen, leaving me to things. There are times when... well, HE makes sense. Is that a good thing? Should I actually want to have HIM around? But HE also acts like a crazy person and gets me on people like Santos's radar. That's not fucking helping anyone — whatever point HE's trying to prove. This is not a fucking good start to the day. Hope my plan with Bob works out. If I can get my hands on that newspaper, maybe I can get some clue as to what HE'S fucking up to.

9:57 am

HOLY SHIT! It worked. Bob has a thing for salt packets. I think I've turned him on to a new hoarding passion that could potentially even spread to sugar and pepper packets.

I opened up a whole new world for Bob. That was a win, but once I took a look at the paper, I'm not sure what I've really gained. I have no idea what HE saw in it, other than the amusement of the crazy sightings. I've torn out the section in question and stuck it in here for you to see (and for me to analyze). I'm not gonna say they're not entertaining. If I had to pick one of these that I'd like to see, well, I'd love to see Tyrell in black dreads. But was HE just fucking with me? Was this all just smoke and mirrors to distract me from something else HE's really doing? Is there something I'm missing here in this? Some other trick? Or is HE just laughing HIS ass off while I run around like an idiot trying to follow these clues that mean nothing? It could totally go either way and I have NO fucking idea. Do you see something I'm not seeing?!?! Shit. I gotta get a grip. Whatever HE's trying to do is working and I can't let HIM get to me like this.

11:49 am

I've been thinking about my dilemma and what I would say to Krista if I could talk to her to help solve this. I really need her input on things, but I'm just not ready to go full disclosure with her about HIM yet. I'm totally on board with the idea of a deal to be honest with her, but I mean... that's allll the way. I think I'd need to ease myself in before giving it up. But I need any and every idea she has about how to keep myself from straying from the path, i.e. TO NOT LET HIM TAKE OVER. Whether HE's sometimes right or not, HE's confusing the situation too much and HE's reckless and HE's fucking everything up. I need to keep on the plan to get rid of HIM to be able to deal with things my own way.

3:11 pm

On the topic of keeping control (and without a Krista presence to tell me what to fucking do) . . . This sounds totally dopey, but whatever, I'm not trying to impress anyone anyway. Okay, so, I went to the library and looked up a book that had some methods of how to work on staying present. There are these little tricks that you can do to ground yourself if you start to feel overwhelmed or lose your sense of being present. I know, I know . . . I HATE this kind of talk too. Why don't I just hang a "Be Calm and Carry On" poster on my cell wall? Shoot me now. Okay, now putting aside all the judgy shit, I'm gonna try it.

There's a five-finger tap. Five different things to do for each finger. The finger thing doesn't mean anything, it's just a way to remember them.

① Take deep breaths. Feel them flowing in and out of your lungs. Breath in for five counts, hold it for five counts and breathe out for five counts.

② Reach down and feel something concrete—e.g., if you're sitting in a chair, touch the legs that go to the ground and are holding you stable. Literally feel your presence in the chair. You can do this with anything as long as you really feel it to bring you to thinking about where you are in the moment.

③ Listen. Stop to take in all the sounds around you—air conditioner, a car passing, people's conversations. Let them in to make your body's sensations less overwhelming.

④ Look around you and name everything that you see in your environment. You can do this in alphabetical order if you're really wanting to take it up a notch.

⑤ This last one's a little odd. It's called tapping. While you're talking about what makes you emotional or anxious, you're supposed to tap certain points on your body and it's supposed to make you feel better or something. I sorta drifted a

1 _____

places to tap if you wanna 3 look like a freak

2 _____

4 _____

bit on the explanation of this one, but I remember how to try it. Spots to tap are your chin, the outer edge of your hand, right above your eyebrow and in your armpit. If I get desperate, I'll try it, but only in my cell. NO ONE can see me doing this.

5:51 pm
I spent the whole time in the laundry room feeling all the fabrics. That coupled with the sound of the machines going through their cycles was pretty soothing. Wasn't so bad. I'm kidding, of course. It was stupid as fuck.

7:41 pm
At dinner, I just let Leon tell me the entire plot of the M.A.Y. episode "Paul Slips in the Shower." I just blocked everything ~~out~~ else out and focused on every word he said. It actually sounds like a pretty good idea. The title pretty much says it: Paul slips in the shower and the episode is all in that moment when his life flashes before his eyes. It goes through all these different memories he has while some therapist type explains the concept. One thing he said that was interesting is that the images you see may all seem random and scattered, but they might actually all be expressing one common desire. It's kind of a cool thought that in the end every behavioral action you've been making and all the choices you've chosen up to that point stem from one single goal you've had for your life. Who knows if this is really true, but it's a theory I kinda like exploring. I wonder what my desire would be. Paul thought he always wanted to win. He just wanted to come out on top. But in the end, he realized he'd already won because he had Jamie and the baby and all that. What's my Jamie and baby and all that ??

I guess my gut instinct tells me I'd want to be normal. I suppose my lesson would have to be that my actions lead me to be the opposite of that. Everything I do, especially

in the last six months, always results in setting me apart, keeping me distant and unrelatable and alone. So all my actions are continuously leading me further from my one desire. Especially the creation of HIM. So then, if I think about it even more, it brings me to the question: Do I really <u>want</u> to be normal?

10:18 pm

Okay, I'm not done with that question. I've thought on it some more. I don't think normal is the right word. I think it's happy. Normal is too nebulous and subjective. So is happy, but I think that to be whatever I think is normal is just to feel right. To not be afraid of who I am. I want to believe that the other people who understand who I am are okay with me as is and accept it. At least a few people. That would make me happy. The weird thing is that I sort of have that already. It's like I'm having the same realization as Paul. But there's something in me that won't accept that like he did. It was all so simple how he tied it up in a bow and just told Jamie he loves her and doesn't need to win even if he can. I still have a compulsion to do those things that keep pushing me away from people. To act in such a way that keeps me apart. Is that what I have to accept? That that's who I am and I'll never be who I think I want to be? Are those the moments that will flash before my eyes?

In an effort to not keep myself apart, I went to the library to read the Vonnegut book Carla gave me. She was in there. I just sat next to her and started reading. She looked me over for a second and kept reading her book too. It was kinda nice. Until I saw a new, nasty bruise on her arm. I gotta stay focused on me, though, right? The regimen. That's all I can handle right now.

And like I said... BORING

May 23

6:41 am

Still haven't seen HIM. It's kind of freezing, I think. I'm still not sure how I feel about it. After that exhaustive soul-searching brought on by a fucking episode of M.A.Y., I'm taking the day off. Not from the regimen but from taking everything, including myself and my fucking life change, so seriously. It's gonna drive me off-the-charts bananas if I have to think about it all so intensely all the time. I'm not saying it's not good to do some introspection— That's what I'm here for, after all—but today I need a break.

9:23 am

Thank god whoever does our new menu agreed that it's TGIF and we got pancakes! They were a bit lumpy and bland, but I don't care. Just what I needed. Leon even gave me one of his. When Hot Carla saw Leon give me his pancake, she gave me hers, too. So I asked her if she doesn't eat carbs. Leon's eyes got all big watching this interaction and he was just quiet and listened. This is what she said: "No. Carbs are for fatties, fatty." It was great. Leon started laughing and said he didn't want to say anything but I have been putting on a few. I ate those pancakes right up with pleasure. I think this day's shaping up to be a good one. That'd be nice for a change.

11:48 am

Ralph's cousin snuck him in an old iPod with music and stuff, so he rigged it up to some speakers during kitchen duty. We listened to an old episode of Howard Stern where they had on this guy who invented the Sybian. I'm not gonna get into it here... you can look that one up yourself. I'll just say that it probably wasn't the best topic of conversation for a buncha guys in jail together.

1:36 pm

Chicken-fried steak. Fried okra. Grits. It was a Southern comfort food extravaganza. There was even apple pie. I was perfectly content and all was going just dandy until I was right behind one of Santos's guys who messed with Carla and fucked me up - Albert. Guess things were getting too calm and controlled for HIM, so HE took it upon himself to take over and push Albert. He gave me a pretty fucking swift slap to the cheekbone. Jesus, I know people hate to take a punch, but sometimes an open hand can be so much worse. That's all I got from him, though. He knew the guards had eyes on us and they won't tolerate much more than that. I think, considering the infraction, he felt he got me good enough to put me in my place... for now. He did tell me to watch my back and that he was happy to serve me up more of what I already got. Great. Who knows what he'll do when the guards are looking the other way.

Not sure what the fuck HE's trying to do. HE's the one who wants me out of that situation, but now I've drawn even more attention. I'm sure Albert will tell Santos what happened. These guys in here take their crews seriously. You mess with one of them and it's an act of war. Maybe this time Santos will get more creative than a good old-fashioned beatdown. But that's what HE wants—to show me how bad things can get in here. I know HIS ways. HE thinks this game of chicken will get me to blink first. But... I've always been good at taking a beating. ← ME

Instead of playing the usual game of basketball, there was a serious competition of HORSE going on. I'd never heard of the game, but it's definitely an easy one to catch on to pretty quick. There were a ton of guys playing, so they did lightning rounds. I was kinda caught up in the action, and when it got down to the final two, they ran out of time. I mean, it was bullshit. They were so close, but rec time was over and this hard-ass guard named Lone Star (obviously not his real name, which is probably Chester or Darryl or something Texan) wouldn't let them finish. He's a real dick, and I think he sorta enjoyed fucking up the game. I guess they'll finish it tomorrow, but something took the wind out of it for me.

I wandered over to Hot Carla, who was smoking under the bleachers. I saw Santos and one of his buddies giving Carla and me the evil eye. I kept him in my sights and they eventually bailed anyway. I'm sure if they make another move it won't be in broad daylight in front of Lone Star. Carla and I just hung in silence for a bit, and then she finally offered me a cig. I took it and then we just kinda started talking. Really her more than me. For a second, it felt like we were just two friends hanging out in a park or something. It's weird how much I buy into my coping world sometimes. It's actually working pretty well, and it's nice when even for just a small moment, like this one with Carla, everything can feel normal. So, she's from North Carolina, but she's lived up here for a while. Had to get out of there for obvious reasons. She didn't go into too much detail, but it's pretty clear his parents weren't okay with her.

5:48 pm

Laundry. That's all I have to say about that. Really wish
I could get on another afternoon detail. I wonder what
Hot Carla does.

He never asked. It's kitchen and laundry — just
on the opposite shifts from him.

7:43 pm

Leon has been doing some research on Paul and Jamie, the real
people, and other stuff they've been in. He's never seen
As Good As It Gets, so he says he's going to check that
out. That is actually one movie I really, really like. An
OCD loner who can't help but alienate everyone by opening
his mouth. Now that I get. Plus, that dog... you can't
help but love him.

I noticed that the non-carb-eating Carla snuck a piece of
bread in her pocket at dinner. She caught me looking, but
I didn't ask and she didn't offer an explanation. Got to
get to the bottom of that. I think I'm clearly making headway
with her. Baby steps.

10:23 pm

Not sure if church group was the right tonal capper to this
day. Probably shoulda thought that one through. There was
some depressed guy, Lyle, who just couldn't stop crying. Everyone
was being all helpful and consoling, but not me. I tried to
leave about six times and kept getting pulled back in somehow.
One time, this dude roped me into a group hug. You heard me.
I don't think I'm exaggerating by saying that might've been
the most fucked up experience in this place yet. The thing is,
Lyle was crying because he's convinced the world's ending.
That Armageddon is around the corner and this hack is
just the first of many signs. Says Tyrell Wellick is the
Antichrist and Evil Corp is doing the work of the devil.
He's right on that last count. His ravings got Kevin
into spouting off about how Wellick's just a crisis actor

hired by the government and the whole thing is a sham, just like Columbine. Yeah, Kevin's a straight-up, legit, off the reservation truther. Started quoting Frank Cody and the theories he's been spreading about Five/Nine. I can't really work out why they think the government would want Five/Nine to happen — but that's always the way with truthers. Their theories don't ever seem to add up. It's all about looping in angry jargon and concocting an elaborately ridiculous story to distract you from the fact that there's nothing at all to their argument. That their main goal is probably just fame and money, and propaganda is just their form of entertainment. Basically, he was trying to calm down Lyle by saying that he's giving in to the fear the government's media machine was churning out. He's playing right into their hands. If they can get you scared, they can control you — and that's exactly what they want.

This, of course, was too much for HIM to resist and the question was answered: NO, HE didn't mean it when HE said HE was staying away. Anyway, HE started mimicking Kevin and really hamming it up. I have to admit, it was pretty funny and I wasn't even totally pissed HE came back. HIS best gem was: "C'mon, Lyle! There's not a single bit of truth to this data encryption mumbo jumbo! They don't even keep those records on computers! Computers were just created to sell to us so they could spy on our every move. In fact, that's why they even convinced Jobs to name his company Apple — to represent the tainted fruit the snake lured Eve into committing original sin with. Get it? It 'opened her eyes' just like using an Apple computer opens their eyes into all your business!! It's just so obvious!!" HE went on and on, spinning it into a nonsensical diatribe. BUT... after a while, I realized that it wasn't HIM talking only to me where no one else could hear. IT. WAS. ME. I said all

of it out loud to the group... and that's when I realized again how fucked I am.

May 24 For the record, I think this is the opposite of fucked
 up. HILARIOUS.
6:43 am

That's definitely going to be the last time I talk in church group for a while. I may lie low for a bit too. It drew too much attention. I don't want any of these guys, least of all that psycho Kevin, trying to buddy up with me about my penetrating insights into the government's conspiracy to dominate our minds.

9:43 am

As usual, Leon heard everything about my church group outburst. He said he never knew we were so on the same page and went off on the idea of a secret cabal that Steve Jobs used to be the chairman of. He couldn't go on much more without busting out laughing. For a second there, he had me going. He was worried that I'd been hiding a crazy side from him—little does he know. I just told him I couldn't sit there quietly while those loons were teetering on the brink of insanity. I think I did a good job of hiding what I know to be definitely true

 ... that there is a secret group of people out there
 secretly running the world.

I changed the subject and asked who ratted me out to him, and he shrugged it off, saying he overheard some guys from the group talking about my philosophy on Apple's spying program. Apparently, they think I'm a genius. He says he keeps telling me: This ain't a place to keep a secret.

11:40 am

Leon was right. These two guys from church group, Flaco and Rupert, found me and asked me if I'm a Codyite. I gotta shut this rumor down, so I just told them Frank Cody's an idiot who gets his truth from Fox News and Alex Jones. Neither

of them had heard of Alex Jones and I'm pretty sure they were headed to the library to check him out.

1:47 pm
When I told Leon about Flaco and Rupert, he confirmed just what I'd suspected. They went straight to the library and wanted to know anything and everything about Alex Jones. Leon directed them to a section he'd created of right-wing idiots. That'll have their heads spinning for weeks.

JULIO

4:15 pm
The big HORSE championship is complete. It was a real upset by a dark horse (pun intended) named Julio. He's a shy, kinda quiet guy who doesn't really have many friends around here. He beat out the fan favorite, Curtis. I actually think Curtis is a pretty stand-up guy who won't take any retribution — just can't be sure the same can be said for his friends. Lone Star had some extra backup on the court just in case.

5:50 pm
Got a buncha bloody sheets dumped in the laundry room. At first I thought Julio didn't get off scot-free, but then I saw him dumping off some loads. So if it wasn't Julio...? This is when HE decided to jump in with some theories. Maybe Santos went further than I thought? Could this blood be from Carla? Or even Leon? Santos knows I work laundry — is this his warped, elaborate showing of the pain he can inflict on me and my friends? HE's really getting in my head... or is it this place? Being in here really fucks with you... you never know who's coming at you and why... and there's never a time you feel totally, wholly safe for yourself or even the few people you care about. So I have to find them fast.

7:23 pm

Couldn't find either one at dinner. About to be in full-on panic mode and HE is loving it. ... I do have to say that beneath HIS smile I can tell HE really seems more pissed that I care so much about the two of them.

10:48 pm

It's past lights-out, so I can't really see too well. Gonna keep it short. Good news to report. Sorta. Leon and Carla are all fine and good, saw them at the special Saturday-night screening of White Men Can't Jump — an obvious attempt on the brass's part at smoothing out the fight from the HORSE game. Turns out, Curtis got a beatdown from some dude who had a shit ton riding on the game. Leon went and visited him in the infirmary and said it looked worse than it was. Says Curtis'll have a pretty nasty scar across his cheek from the broken bottle the guy used to slice him good.

May 25

He just grabbed my book and drew that as a little wake-up hello since HE can't do anything else. I guess you could say HE's feeling a bit impotent. I know I've had my doubts, but I think this regimen's working. HE seems totally frustrated. Good. Three days and no losing time, I think HE's getting weaker and my control is getting stronger. Maybe I'm on the right path and it is just a matter of WILL.

RISE AND SHINE

9:51 am

Sat with Leon and Hot Carla again this morning. I saw her hide
away a bit of her biscuit in a napkin. I thought maybe she's a
secret eater. I think the chubby guy did that sometimes
too. I mean, he didn't hide it all that well, but he's got
a nervous eating habit for sure. And when I was around
him, I think his nerves were pretty shot. Carla doesn't
seem all that nervous, though. In fact, she's pretty even-
keeled for someone who deals with all the bullshit she's
gotta put up with around here. I hide it well. Pretty much every
minute in that place, I was on edge.

So of course I decided to follow her after breakfast. She
went back to her cell, and that's where I met Reynaldo.
She was waiting for me. I must be terrible at surveillance
or she's really good at sensing when she's being followed.
I guess she's had to develop that sense around here.
Anyway, at first she was
mad, as usual. She doesn't like
me sneaking around her, she
said, and she asked why
I'm so curious about her. I
didn't really have a good
answer. I just said I wanted
to know why she keeps stealing
food from meals. Then something
moved in her pocket. I clearly
saw it and she angrily
denied it. I wore her down, though, and that's when
she pulled him out. Reynaldo. He's her pet rat. Gotta tell
you, was NOT expecting that. He's pretty gross, but Carla
is very much into him. I get it. He's her only real
friend in here. So in that sense, it's sweet. She says she's
had him for like five months, and he does actually seem
pretty well trained. For a rat. They even have one trick

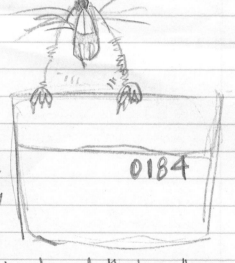

0184

they do. Carla holds up a morsel of food and Reynaldo runs in a little circle for it. It's pretty basic, but I've never seen a rat do a trick, so it gets some respect. After he ate, Reynaldo ran right up my sleeve and then hung out on my neck for a second. I could feel his whiskers twitching against my skin, which was sorta cool but fucking disgusting.

I told her about Flipper. Carla seemed really sad about her having to go back to that abusive shitbag. I think Carla can sort of relate to that situation. I asked her about Santos. She just shrugged and said putting up with guys like him comes with the territory and is a necessary evil to her survival. She said it's better not to cause too many problems about it. I've heard that kind of thinking before and, while I want to help, I know how that turns out too. She, just like Shayla, isn't asking for a hero. And you and I both know I'm no hero.

11:43 pm

Carla and Reynaldo reminded me of a time when Darlene and I were kids. My mom would never let us have a pet, no matter how much we begged. Darlene was animal-obsessed. Me, not so much, but I liked them fine. It just didn't seem like anything that would ever happen, so I took the idea out of my mind. She wouldn't let it go. She was so jealous of all her friends who had pets. Well, one day when Darlene was 6, this friend of hers — Meghan, I think was her name — had a cat that had kittens. Without telling my mom, Darlene took one. It had cool eyes that were green with lines all inside them. They looked like maps. Darlene named it Moon Pie after her favorite cookie, since she was black

white, and brown. Those moon pies are pretty fucking good. So, for a while she kept Moon Pie hidden in her room, but she knew that wasn't going to last too long without our mom getting wise. After a while, she made a little house for her way out back behind our yard and kept her around as an outdoor cat. It seemed to be going okay until, one day, we were driving to school and our mom took this weird detour to Schlegel Lake. She pulled a bag out from under her seat and gave it to Darlene to hold. There was something inside. It was moving and then... a meow. Darlene instantly started to cry and pleaded with my mom to let her keep Moon Pie. She opened the bag and little Moon Pie poked her head out, looking terrified. My mom stopped right by the lake and told Darlene to tie up the bag and throw Moon Pie in. Darlene refused and held Moon Pie close. Then she jumped out of the car and ran. My mom got out, yelling at her to come back, but Darlene just kept going. I was so happy and I just hoped she'd run forever and never turn around.

Well, she ran for a long time. She was gone for three days. My mom called around to some of her friends' houses but was too worried about what everyone would think of us. I wish I could say I couldn't believe it, but I wasn't surprised. I went around to several hideouts we had. I checked movie theaters, went to the zoo, and asked around with her friends. Couldn't find her anywhere. Then, that third day, when I came home from school, I went out to Pile of Rocks. That's what we called this place where we'd go to play because, well, it was a pile of old rocks. There was Darlene, bruised and crying. A neighbor up the street had found her hiding out in his toolshed and brought her home. My mom went to town on her, pulling out all the stops — she dug her nails real deep.

When she saw me, Darlene just smiled. Even with a busted lip and scratches, that girl just smiled at me and said,

This part, I like. →

"Hey, brother. I won and it was worth it." She knew she'd eventually have to come back, but she just wanted to make sure Moon Pie was safe. She found her a new home with this nice old lady a few blocks away and her mission was complete.

1:43 pm

Leon was blabbing about M.A.Y. as usual today. It was an episode where Jamie and Paul keep arguing so much that their therapist says they aren't listening to each other enough. She tells them to go the whole rest of the day without talking and only communicate with gestures. Goes pretty well too. They end up getting all hot 'n' bothered and almost get to the point of doing it on their couch. But, true to classic comedy gold, they're interrupted. I think I could go a pretty long time without talking. I do it all the time. The best part — and something Paul and Jamie learned too — is that when you don't talk, other people tend to tell you even more than they usually would. Just to fill the silence or unburden themselves. Maybe I'll try that technique on HIM. Not fill in the silence. See if that will push HIM to the edge.

3:49 pm

Funny that just the thought of ignoring HIM brought HIM right to my side. HE sat next to me during the whole basketball game today and was obnoxiously cheering. When HE saw me eyeing Carla HE laid into me about how I'm just collecting another charity case and I've already gotten myself into enough trouble with it. HE asked me how much worse I want it to get. And since I'm ignoring HIM, I gave HIM no answer and HE just went on saying how I never know how to really lie low, how I'm just full of shit with all my good intentions, and on and on and on.

... I just let HIM talk and didn't say a word. I could tell that really got on HIS nerves. You know, HE's like Frank Cody. HE thinks HE's always the star of the show,

the titular character—and he can't stand being ignored. This feels _so_ good ...

5:55 pm

Don't have a lot of time. Shit went down in the laundry room. I was minding my business, still ignoring HIM, while HE just followed me around reading out loud from Penthouse, when Hot Carla came running into the room. She bolted for the linen cage and hid behind the racks. She looked so scared that I just knew what was happening. I instantly locked the lock on the doors and went back to my folding.

A few minutes later, Santos and his other guys ran in, clearly looking for her. One had claw marks all down his cheek that were deep and bleeding. They fanned out and searched the place. Then they asked me if I'd seen her—they didn't say her, they said, "That he-she hiding in the pillows down here?" I gave them my best I-haven't-seen-shit stare. They kinda got annoyed and one came up real close on me, so I said, "I don't even know who you're talking about." He gave me his best menacing look and said, "You know who... Hot Carla. We've seen you with him." I said nothing, though HE got on my nerves by jumping and screaming in the corner, pointing, "Over here! Over here!" Then HE laughed and told me not to get upset. HE'D never rat out Anne to the Nazis. Hilarious. Yes, that was sarcasm. HE'S already made it abundantly clear HE hates that I look out for Carla... but I know that what HE hates even more is that we're actually becoming friends. That's what terrifies HIM the most... that I could be comfortable with someone else, that I can make a friend and not need HIM. It makes me stronger to make it in here.

Anyway, those assholes finally gave up and left. I waited a long while, finished some washing to give Carla some time alone, and then I unlocked the door. I just left it like

that, didn't bother her any to come out, and she stayed in there a little longer. When she came out she told me she hates the name Hot Carla. I asked how she got it and she said she did like Carla. She took the name from a super fabulous hairdresser who used to do her mom's hair. Back when Carla was a he, her name was Jack. He loved sitting in the salon with his mom listening to all the ladies gabbing and getting pretty. Sometimes Carla would joke around and paint his nails, but his mom, knowing something wasn't right with him, would just get pissed off and make Carla take it off right away.

One day, when Jack got caught by his dad playing dress-up in his older sister's prom dress, his dad beat the shit out of him and he ran away. Jack ran straight to Carla's and told her the whole story. Carla knew right off what Jack was, but she knew there wasn't much she could do but listen and be there for him. When Jack got kicked out of the house a few years later, Carla was the one who gave him a job. She let him rent the apartment over her salon and work for her, learning the trade. So, all these years later, it only seemed fitting that he take the name of his most favorite woman. But now the jerks in here have tainted that name. She said she sorta doesn't mind it because she does think she's hot and, well, she does love fire, but there's the other meaning that really pisses her off. I told her that if it counts for anything I liked it because of the other two reasons, not for the one involving shit. (Look it up if you have to — though I wouldn't recommend it.) She smiled. The first true smile I've ever seen out of her. Then she said I could call her Hot Carla and she left.

HE made fun of Carla, saying everyone's got their sob story and they don't need to go sharing it with the world. I'm getting an unsettling feeling that HE's gonna hit a breaking point soon. Just something I can feel coming.

7:54 pm

I fucking <u>knew</u> HE was itching for some attention, though I didn't know it'd come this fast. After laundry duty, I passed Santos and his guys just lurking around trying to put the threat on me. I was happy to just cruise by, ignoring them, but HE couldn't resist. HE just fucking took a swing right at Santos— nailed him in the face. It was ridiculous, Me against three of them. It was a totally stupid move, but they were caught off guard so HE got a few good punches in — not gonna lie, that felt good. But they weren't surprised for long and all jumped me together. A few other guys started gathering around, It was hard to even see out from inside the fight, but I could hear cheering. While Albert and that other guy whose name I don't know were taking turns getting some kicks in, Santos was rallying the crowd like a fucking ring-card girl. At that point, I was just too outnumbered and outmuscled. I still landed a few kicks back, but then I was done. I curled into a ball and just hoped it would end — unsure if I was just going to get lost to unconsciousness and never wake up.

I didn't think I'd ever say this, but I was lucky that Neanderthal Kevin from church group saw us. He jumped in and broke it up. They landed some pretty fierce blows. I've got plenty of bruises, think I cracked a rib. I guess my blabbing in church group got me on Kevin's good side. For this moment, that was a good place to be. He has a lot of pretty ruthless friends, so I think Santos and his guys might think I'm under their "protection" now. I hope I don't have to make it up to Kevin anytime soon. Unfortunately, Lone Star wasn't too far off either and we all got busted for disorderly conduct. I took the brunt of the blame this time since witnesses corroborated with Santos that I started it. Thanks to HIM I'm no longer on fucking

laundry. Thought that would be a good thing, but not when they're looking for a chore to punish you with. So I just spent the rest of my night cleaning fucking toilets. I've moved from shit stains to actual shit. Everywhere too. It's like these idiots couldn't find a toilet if you duct-taped it to their ass.

So HE'S made HIS point. Even if I keep HIM from taking over, HE can still fuck with me. I get it. And I'm not sure how to control it yet. But I'll figure it out. Now HE'S bolted. Haven't seen HIM since the fight. Oh, and speaking of shit, now there's no question HE'S got me permanently on those assholes' shit list. Not HIS smartest move to date, but HE just wants to put the pressure on any way HE can. Won't help HIM much if we take a shiv to the gut before we get out of here. After all, doesn't HE die if I do??

10:23 pm

This day just got longer. Found out those guys caught up with Carla and she ended up in the infirmary. I went to see her and ... well, it was pretty bad. She was completely out of it. They said they weren't gonna touch her face because they didn't wanna have to put a bag over it to fuck her ~~up~~ from now on. So instead they broke her wrist and then took turns raping her. She still doesn't want me to do anything, but she didn't make me promise. Either way, I'm not gonna act rash. Gotta think this one through. I obviously can't allow Santos to exist anymore. But how do I delete someone in an analog world?

My Wound Inventory

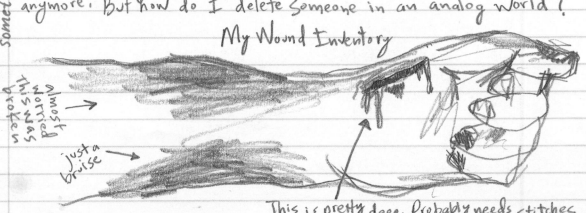

almost worried this was broken

just a bruise

This is pretty deep. Probably needs stitches.

I think a part of him has a death wish ... even if it's deep down I know sometimes I do.

HEY, I'M NOT TOTALLY HEARTLESS. AND, CONTRARY TO WHAT HE THINKS, I DON'T CARE IF HE HAS A SOFT SPOT FOR HOT CARLA. WHAT HAPPENED AND KEEPS HAPPENING TO HER IS A RAW DEAL AND I FEEL BAD FOR HER, ALL RIGHT? THAT STILL DOESN'T MEAN HE NEEDS TO GO POKING HIS NOSE IN THIS MESS. I MEAN, AM I ACTUALLY REMINDING HIM OF WHAT HIS WHOLE PURPOSE IS IN HERE? HEAD DOWN, GO UNNOTICED AND FIX HIMSELF. NOW HE'S STRAYING AND IT'S NOT MY FAULT. SEE? HE REALLY DOES NEED MY HELP — EVEN WHEN IT COMES TO GETTING RID OF ME! HOW DO YOU LIKE THAT?!?

May 26
5:37 am
Woke up to HIM doing multiplication tables or something over and over again. HE was just spouting numbers nonstop. It was almost trancelike. For a while, I tried to listen and figure out what HE was doing. Some stuff wasn't even adding up right. I think what I'm doing is working and he's losing it.

9:55 am
I told Leon about Carla at breakfast. For once, I told him something he hadn't already heard. I could tell he was pissed. He stayed quiet pretty much the whole meal, which was kinda unsettling. I'm not used to a quiet Leon.

So I focused on the paper for a distraction. Not so much of a distraction when I see more Five/Nine news, which only gives HIM more stuff to get amped up about. I was getting sucked into an article about some foreign hackers when I noticed Leon was staring at my bruises. I got self-conscious and asked him what's up. He says he knows I wanna help Carla out, but things don't really work like that in here. He said it's probably best to keep

to myself and let her take care of her, BUT if I don't listen to him,
I better be very, very sure to cover my ass, and right now my
battered fucking face doesn't look like I'm covering my ass.

11:47 am

NOW THAT i'VE GOT YOU TO MYSELF, LEMME JUST SAY THAT THERE'S NO
REASON FOR US TO BE AT ODDS, RIGHT? WE BOTH WANT WHAT'S BEST
FOR ELLIOT. SHIT, I'M SUFFERING IN THIS LITERAL PRISON TO LOOK
OUT FOR THE KID, AND YOU CAN'T BE ENJOYING ALL THIS BLAH—
BLAH—KUMBAYA KOMBUCHA HE'S FORCING YOU TO DRINK. HE'S
GOTTA FACE FACTS, AND THE ONE GLARING, OBVIOUS PROBLEM IS
HE'S DELUSIONAL. SO HE'S THE HE IN THIS SITUATION, NOT ME.
WE GOTTA HELP HIM BREAK OUT OF THIS TRANCE HE'S IN BEFORE
IT'S TOO LATE. HE DOESN'T NEED SELF—HELP. HE IS THE HELP.
HE'S THE ONLY THING THAT IS ACTUALLY MAKING THIS WORLD A
BETTER PLACE, AND NOW HE'S CHOSEN TO JUST SIT BACK AND
TIE MY HANDS, OUR HANDS. THERE'S SO MUCH MORE TO BE DONE.

For the record, HE DID NOT just take over. I cleaned those
nasty-ass fucking toilets. and when I came back to write,
HE took the journal from me. I was totally awake and
watched HIM write that whole thing. When I just read it,
though, it took me a second to make sure, but HE was just
fucking with me to make me think I'd lost time. So we're
god good.

Santos and his idiot cohorts were cracking jokes about
Carla in the bathroom..., just loud enough to be sure I
could hear. It's all my fault — what happened to her. Well,
it's HIS fault and I told HIM so. If HE hadn't attacked
those dickwads, I don't think they woulda gotten amped
up enough to go after her like that. They were teaching us a

I don't think he knows how to follow any rules — in there or
anywhere. It's one of the reasons why I like him.

lesson....while HE was trying to teach me one. Too many fronts I'm fighting right now. Maybe HE's proved his point that I shoulda stayed out of the Santos thing, but it's too fucking late. Gotta keep looking over my shoulder every day. Who knows if those guys are just gonna keep coming at me now that I'm their prime target. Anyway, that's my problem, but I shouldn't have let it spread to someone else. Doesn't matter whose fault it is, HIM or me — what fucking sucks is that Carla's paying for it, and that's kinda hard to live with.

1:45 pm
Leon said he has a visitor coming today. Some old friend from his neighborhood or something. He was acting sorta cagey, so I let it drop. When I was walking by the visitation room after lunch I saw him with a nerdy, cute Asian girl. I wonder if he was being weird because she's his girlfriend or something. They looked pretty serious, whatever it was they were talking about.

I saw him with this girl several times too. I didn't get the vibe that they were dating, but their talks always seemed intense. Wonder who she was?

3:51 pm
I'm trying to lie low, so I didn't go to the game today. I wanted to see Hot Carla anyway, so I went to visit her in the infirmary. I finished the book she gave me. It was pretty good. Not Vonnegut's best work, but it had some interesting food for thought. One thing he talked about was practicing art. This is what he said:

> "Practicing an art, no matter how well or badly, is a way to make your soul grow..."

He goes on with some lofty ideas on how to expand your mind, but the one that hit me was:

> "Write a poem to a friend, even a lousy one. Do it as well as you possibly can."

Okay, definitely obvious and corny self-help-y in my opinion, but he's a smart man who I respect, so I decided to do something totally out of character for me (which is the whole point of what I'm doing in here, right?...) I wrote a poem for a friend. Sorry, friend, it's not for you and you'll never see it. It's totally embarrassing and lame. He said it could be lousy anyway... which it was. I don't even know what kind of style or pentameter or whatever it ended up being — I don't know that shit and I'm gonna keep it that way. It was an exercise in being someone other than fucking me for a while, so get over it. Yes, I realize that it sounds like I'm trying to convince myself I haven't gone completely soft in the head. Again, fuck off.

So I took my book and my poem to go see Carla. She was not happy to see me. I don't blame her. I guess there's no doubt in either of our minds that I was the cause of her latest and what seems like worst attack. She was pretty much giving me the silent treatment. [The worst part is that I can't really explain to her what happened. I can't tell her that my psycho, masochistic, dead father figure was just trying to win an argument with me and, oh, sorry, she got caught up in the mix. Nope. That won't work.] So all I could say was I don't know what I was thinking and I'm sorry. I let this place get to me. Still... no response from her.

I told her I finished the book and I could see just the smallest flicker of interest, but she still stayed mum. I also brought a book of matches Leon got me and asked her if she wanted to burn the book in the bedpan. I could tell she was surprised that I knew about her burning books after reading them. Finally, she spoke and said no because she hasn't read it yet. Here I thought she was sending me some big message in this book and she hasn't even read it!! She just shrugged and said she liked the cover.

If only he'd tried to tell me... well, what would've it changed at that point?

I felt pretty stupid for writing her the poem at that point, but I went ahead and gave it to her anyway. I made her wait to read it after I left, though. I absolutely could not have stood there like an idiot while she read it, and things were starting to get awkward with her being so pissed off at me. I started to leave, but then I asked her why she burns books after reading them. She smiled and said that was something she wasn't ready to tell. I nodded and left her alone.

I like it when she keeps a secret like that. It's rare to find someone who isn't just _dying_ to tell anything and everything about themselves to any old fuckface who'll listen. Look, I'm not opposed to being open and sharing—well, I am, but I should be better about that. But I've fucking _had it_ with a world in which Instagram and Facebook have become reasons to do things with your life. Just snap a pic and suddenly the experience is validated. Now your life is interesting because everyone knows about it. But while you were in the middle of something amazing, you had your nose down picking the Nashville filter and missed what it was you were really doing. In the end, nobody fucking cares. In fact, you're just making them jealous of your faux experience, so they just like you even less than they will when you come home raving about Bali. So if you wanna go to Bali, go. _For you._ Enjoy it. Live it and don't fucking hashtag about it.

Yes, that was still all me. Not HIM creeping in. Look, I'm working on trying to be a better person, but I'll never be a totally different person. So as long as Facebook's around, well, I'll pretty much still bitch about it,

I think they're gonna let Carla back out tomorrow. Seems a little soon to me. Especially since those pricks are still hanging around, but I guess there's no escaping them anyway. She said she had to talk to the jail therapist, not that it was all that helpful. Reminded me that I want to contact Krista. I doubt she'll even take my call... maybe I'll write her a letter since I've become such a prolific writer these days. Either way, I need to apologize to her. We'll see what happens beyond that.

5:50 pm
I've got no fucking love for latrine duty. It's pretty much the very worst thing to do on a daily basis. BUT... I do have to say that spending so much time in the bathroom is sort of like hanging out in a barber shop. Lots of shit goes down in there. Drug deals, secret hookups, private calls on contraband phones... I guess people feel like it's the least visible place in the whole jail. The thing is, I feel the opposite. It's like you're totally exposed in a frequented area and you don't know who's listening on the other side of the stall. These days it's me. I'm always listening, gathering information. You never know when you'll need it. For example, today I heard Santos on the phone with his doctor telling him it burns when he pees and he needs him to schedule a blood test tomorrow. Being the hypochondriac that he is, Santos has his doctor on speed dial, and apparently he's constantly getting him to do shit like this for him. Interesting information. Gives me an idea. Time to scratch that itch.

7:51 pm
Leon was a little more inquisitive than normal at dinner. He was asking about my family and stuff like that. It was normal shooting the shit for most people, but it felt a little weird between Leon and me. I told him a little about growing up

in Jersey and that I had a sister. Didn't go into too much detail. He said he grew up in Brooklyn. I realized I'd never asked him what he was in for. Seems weird I never thought to ask, but I'm not gonna be the first one to say I'm a little self-obsessed. He just said he was doing a favor for a friend and it landed him here. He said that's how it goes sometimes and you just gotta go where it goes. Is it me or is that a little cryptic?

YES!!!

10:24 pm

I thought about going to church group tonight just to stay on track but figured it's better to stay away for a while. Let things simmer for a bit after my oh-so-stirring rant. I've managed to avoid any of those truthers and wanna keep it that way. I did go to the library instead. I saw one of those guys who attacked Carla — one of Santos's sidekicks. I know, shocking he'd be found in a library, but then I realized he was just using a nude photo in one of the photography books to jerk off. Remind me not to check out Herb Ritts's Africa. Yeah, he was beating it to a tribal woman breastfeeding. If I were a different person, I woulda shanked that guy right then and there. But, that's not the route I'm taking in life.

How is it that that guy is just able to wander around jerking it to whatever bit of skin he can find and Carla's laid up, fucking wrecked by what he's done to her?? Where are the consequences and repercussions? I'm not whining here saying life's not fair, but... well, why is it so rare that it is? Why do the fucking dickheads always win? And why do they feel the need to win in a way that just fucks those of us who are just minding our own business? There are reasons — real ones that make sense and aren't crazy — why I am the way that I am and why I do the things

that I do. And yeah, some of it comes from my hatred for these rules that've been set in place that allow greed and strength to come together in the worst fucking way. It's not just a ~~det~~ detriment to society, it's a plague on the entire human race. We outdo our good with our greed. We waste our ability to choose by always choosing wrong. We just can't help ourselves. Our wants will continue to overtake our choice for right, and that always will be what holds us back. Then again, maybe that's our curse.

May 27
6:40 am

DREAMS DREAMS DREAMS
DREAMS DREAMS

It's weird how much I dream in here — or at least how much I remember my dreams — but I had another strange one last night. Krista, Angela, Carla and Darlene were all having dinner in my mom's house. (The house I'm "living" in right now.) And in the living room, Gideon, Lloyd, my dad and Tyrell were all sitting around watching football. I was just standing in the middle of both rooms, not sure which one to be in. I was watching all of them laughing and smiling. They seemed like they were all having such a good time. I was a little lost, stuck in my space between both groups, but I didn't feel totally alone. It was nice seeing them happy. That's the whole thing. It was almost sort of a feeling, a moment, more than anything else.

When I woke up, HE was waiting for me. Nice of HIM not to wake me up, I guess, but HE was just lurking, staring at me, which was a little jarring to wake up to. HE's getting worried about my "attachment" to Hot Carla. My infatuation with the idea of rescuing her. I know I haven't told you my plan yet, but HE knows, for obvious reasons. You, on the other hand, can't read my mind... yet. But the plan is making HIM even more antsy to get out of here — before I get in too deep. He says for once I have

to listen to HIM or else... I don't know what the "or else" is, but I know I've been here before.

If the whole point of me being in this place is to change my ways, I can't just keep repeating them. The definition of insanity and all that. But I also can't sit with the idea that you can't do [ANYTHING] to make things better. Just because I suck at helping people doesn't mean there isn't a right way to do it. That's what I'm trying to do now. Like: What would Not-Me do?? Is that a bracelet people wear or something they sew on little couch pillows?

9:47 am
Hot Carla wasn't at breakfast, so maybe they're keeping her in the infirmary a little longer.

1:47 pm
When I got back to my cell after kitchen duty, Carla was waiting for me. She said she didn't feel like going to breakfast and thought I wouldn't mind her hanging in my cell since I'm always following her around anyway. She still seemed pissed, but then she softened up a bit when she started to tell me how much she liked my poem, but I stopped her right there. HE busted out laughing at the thought of me writing a poem. I got so angry, I almost lost it and yelled at HIM right in front of Carla. But would Carla have heard it or would that have happened in my head? Rules. Not only do I not understand them, I just plain fucking <u>hate</u> them.

I can tell Carla's a little on edge at being back out with everyone again. I didn't really know what to say to make it better. Got a little awkward, and I was relieved when it was time for lunch. I skipped an entry because I didn't have a chance to write in my cell with all that commotion, so I'm getting it down now.

3:56 pm

The Warden, Ray, was trolling around the yard today with his dog and that shithead Lone Star. Everyone turns it on all friendly and kiss-assy when he comes around. He seems like a nice enough guy, but the phony meter on the inmates goes through the roof when they see him. Everyone wants to get on his good side. I haven't ever talked to him or anything, though I'd like to let him in on what's going on with Hot Carla. I wonder if he knows. If he did, I wonder if he'd do anything about it. He doesn't seem like the shitty kind of warden you see in the movies like Shawshank. I think he goes the benevolent disciplinarian route.

10:21 pm ← Man, did he read that one wrong...

So... I did it. Scratched that itch that's been bothering me. I waited until I saw Santos head to the infirmary and I followed. I gave the nurse a few good lies about night sweats and a potential goiter I've been feeling, convinced her to give me a blood test for hypothyroid. Not even really sure if any of that made sense, but she bought it and it landed me right next to Mr. Santos at the blood-drawing bank. He gave me a look, but I kept it cool, took control and basically said that I'm at peace with him. We're done. No point in dragging out this feud, right? He shrugged. He's probably not on board, but I don't care. What I cared about him really hearing came next. This is what I told him: "It's funny we both had the same idea, and it's a good one. Carla's got a lotta problems and we don't need to be taking them all on, right?" At that he perked up and asked what I meant. I gestured to the needle in his arm and said, "You know. ... I mean, that's why you're getting tested, right? Don't want to catch what she has. That's life-in'-death shit. Definitely not worth it." I mean ... the fucking blood drained out of his face so fast you woulda thought that needle was

drilling for oil. Right about then, the nurses were done with us. I gave him a nod and took off before he could ask any questions. And that's how you plant a mental virus in a hypochondriac's brain. Pretty soon, the delusions will come, itchy jock, red spots, sweats—then the ultimate fear, the permanence of disease, visions of evil cells dividing, multiplying inside of you, spreading to every nook and cranny, never leaving your body until the day you die, perhaps even one day being the happy cause of that death. He's fucked.

I don't even know what to say about this.

May 28
6:49 am

SO FUCKING STUPID. I DON'T HAVE ANYTHING ELSE TO SAY. HE THINKS HE'S BEING COY AND CLEVER AND THIS SOMEHOW WON'T COME BACK TO BITE HIM IN THE ASS. HOWEVER, ALL PREVIOUS SUCH ENCOUNTERS HAVE PROVEN TO THE CONTRARY. STILL, I WON'T WASTE MY BREATH STATING THE OBVIOUS, AND... I'M NOT GONNA STICK AROUND TO PICK UP THE PIECES. I'M OUT OF HERE. FOR REAL AND FOR GOOD. IF I'M NOT APPRECIATED OR WANTED AND HE'S JUST GONNA PUT US ON A PATH OF DESTRUCTION, I'M NOT GOING TO WATCH. HE CAN DEAL WITH THIS ON HIS OWN OR GO DOWN IN FLAMES TRYING.

HE got his hands on this before I could this morning and then HE just left. Good riddance. I'M not falling for anything. I hope HE's gone, but I'll never really believe it. HE's too much of a narcissist to ever really disappear unless I make HIM. HE needs an audience, someone to hear HIM spout HIS bullshit... even if it's just me.

But I think this plan will work. I mean... come on. He's not gonna touch Carla, even to beat her up, if he thinks she might have an STD. That's like kryptonite to a hypochondriac. And if that somehow is also a way to get rid of HIM (even for a little while), then that's just the cherry on top. Done and done and done. I mean... I'm pretty fucking doubtful HE's really gone for good, but the rest of it... I think I did the right thing.

Oh, I also read Angela's letter. Yeah, so, she's pissed. I know it's not cool not to respond, but I don't know what I'd say. I just need some time. I know she gets it. She always gets it. Even if she wants to talk it out, she knows I don't want to and she's just gotta let me make that call on this... well, its my problem, so I can deal with it how I want. Guess that sounds pretty shitty. Especially when she just wants to help. There's just nothing she can do this time. I feel bad that I'm giving her the silent treatment. It's not that I want her to go away — it's the opposite, actually. I want her to be there... always. Just not in person until I'm ready.

9:41 am

Carla wasn't at breakfast again this morning. I think she's gonna keep herself scarce for a while. Leon, on the other hand, was there in full force. Somehow he knows what's up with Santos, of course. Shook his head at me and just said, "I'm of two minds, cuz. One: you did a good thing, keeping our girl safe. Two: you stuck your nose where it don't belong and it's gonna get punched,* probably by that very girl." I just nodded and said, "It was worth it." He nodded back. That was all the chastizing I got from him, and it's fine that he knows. He always ends up finding everything out anyway and I know he's on my side with this one. At least, I _think_ he is, right?

11:53 am

I've been getting some real side-eye from everyone since the Santos virus (as I like to call it). If you make a move on someone like that, everyone turns their attention on you. They don't like someone causing trouble. Makes them wonder if and _when_ you're gonna turn on them. Shit. I hope my plan works.

* I still owe him that punch.

1:46 pm

Well, Carla wouldn't even sit with us at lunch today. She sat a few chairs down. I think she's trying to disassociate herself from me in Santos's eyes. That's fine. I understand. I want to disassociate myself from me too. But, if this plan works, she won't have to worry about that anymore anyway.

Since Carla wasn't with us, Leon still felt like he needed to give me some more advice on things. I think he's just as nervous as I am about the fallout of my little plan. He says he knows the pressure that builds up around here. That it's hard to sit back and let all the bad shit happen. That's half the reason he watches shows all the time. Keeps his mind occupied and keeps him outta shit. He said that's one thing about Jamie and Paul — Jamie especially. She can't even let anything go. She's always gotta speak her mind on everything and it gets them into more problems than if she'd just take a back seat every once in a while. It's her Achilles Heel. So there was this one episode where they decide to write down their argument instead of fighting it out. Then they buried the notes and that's it. That's the end of it. They never speak about it again. Leon said That's what this journal's for, right? Writing it all down so it doesn't build up in my head. He's partly right and it's probably good advice. It just doesn't undo what's been done.

When Carla walked by with her tray, she said to Leon, "When are you going to be finished with that fucking show?" I laughed and Leon looked crestfallen. He said he only has three episodes left.

We watched her walk away, and the plan has worked so far. She didn't notice it but people were looking at her and some were even moving away keeping their distance.

I wish I had!

3:45pm

So Darlene made a surprise appearance today. Wasn't exactly the best timing, but I don't control everyone. Yes, that was sarcasm.

Anyway, she didn't really come for a fight this time. I can tell she's excited by all that's going on out there, but she's not going into too much detail with me. She actually kinda just seemed worried about me. I told her I'd been thinking about Mom some — I didn't get into my whole elaborate fantasy. That's a bit too much for her to handle, I think. But I asked her if she's gone to visit her anytime recently. She thought that was totally ridiculous and doesn't know why I even waste my time thinking about her. So that was a pretty succinct NO. Sometimes I wonder if our mom did more of a number on Darlene than she did on me.

Darlene asked about Angela, if she's come to visit. When I said no, she got pretty pissed until I told her that I wasn't letting her come. I said she'd written me letters, but I just couldn't. I didn't go into too much more explaining. You know how I do it — less is more — and Darlene can read between the lines. She asked if I'm still seeing HIM. That one, I let go unanswered. That was a silence she knew the exact answer to.

So she changed the subject to my "luxurious lifestyle," as she called it. I think she's sorta curious about what it is I do in here all day. I sorta got into my regimen and my chores and all that. I told her about church group and she got a big laugh out of that, especially the truther morons. She said Frank Cody's really amping people up outside too. They've been having lots of rallies and protests and stuff.

It was really, really, really good to see her. Darlene is always my grounding force, even if she's crazy. I didn't realize how much I needed to see someone from the other

side of these walls. It is like a breath of fresh air, as cheesy as that sounds. It's nice to touch on to someone who's real and is a real part of my real life outside this place. It's not like I think this whole thing in here isn't real, but it can sort of feel like a dream — a nightmare perhaps. Like an alternate reality from the real world, like your actual life is just on pause. The problem is, the actions I took in my actual life are making the world outside an ever-changing place. Will I recognize it when I get out? Will it have actually changed all that much? Who knows?? By the time I get out, it might just all have gone back to the way things were and I won't have made a difference at all.

5:58 pm

After seeing Darlene, it sorta made me think I need to let Carla in on what's going on. I need to be a better friend and help her through this rather than let her be a victim of a circumstance I've created. Even if it is all to help her. I don't know what Santos could be planning to do to her, but she should be prepared. If I'm being honest with myself, I think I may have been holding off on telling her because I'm kinda scared of how she's going to take it. But maybe she'll be okay with it. Maybe she'll see that this is a good thing for her. Who gives a fuck what they think if they leave her alone, right? But I do think I should be the one to tell her, so it doesn't come from one of these assholes somehow making her feel like shit. Also, I don't want her to go denying it either. They might believe her and it'll all have been for nothing. Gonna try and find her at dinner.

THE SEARCH
FOR
CARLA

Gotta love him, but sometimes E. sees stuff too much in black and white—good vs. bad. He didn't factor in the brutality that lies in the gray.

8:15 pm

Shit. No Carla at dinner. I've been looking in all her usual spots but haven't found her. Still looking. This is getting really fucking urgent to me now. I've been trying to keep my cool, hoping it was all gonna play out exactly like I planned, but now... I'm not so sure. Maybe HE was right to clear out and not be around for this fallout...

10:29 pm

I was too late. Santos's hypochondria has him totally panicked that he's completely losing it, thinking he is definitely dying. Of course, in his twisted mind, it's all Carla's fault, so he found her and confronted her. I got there, but just a few minutes too late. He was reaming her out for not telling him. For letting him do what he did to her without him knowing she was infected and disgusting. Of course, Carla had no idea what he was talking about. She was embarrassed more than anything. A crowd gathered. I could just feel her shutting down when she started becoming the center of attention. She's like me in that way. She denied all the accusations, but no one believed her. I stepped up to Santos and told him to back off. He let all his rage out, right into my jaw. Fucking blasted me good. He said I could take that for my friend because he's too grossed out to even come near her ever again, much less touch her. Then he left. Carla just sat there, frozen, staring at me while everyone else pretty much dispersed. Leon went and put an arm around Carla and she actually let him. He brought her over to me and told her it was the best plan to keep her safe. She could see that, right? She looked from Leon to me — no smile, no understanding — and just walked away. Leon told me it'd be okay, but I'm not so sure. Maybe she feels like I betrayed her. I don't see it that way, but I _do_ know she's safe. So that's all that matters, right?

May 29

6:34 am

First order of business: Find Carla

9:43 am

Leon hasn't seen her. Shit, I'm really fucking getting
worried. Did this whole thing backfire?? Of course it
backfired. That seems to be my middle name these days.
Motherfucker. I have to find her ASAP

11:53 am

Still no Carla. On the bright side, still no sign of HIM.

1:47 pm

No Carla at lunch, so I took some bread by her cell for
Reynaldo. She wasn't there. I don't know where she
goes when she disappears, but she has a good hiding place.

4:10 pm

No Carla at the yard. I checked the library too. I think
I really fucked things up this time.

I know what you're thinking. Shit, it's probably what even
HE would say at this point. That I need to just leave her
alone. That I of all people know when someone needs their
space and their own time to work through stuff without
someone else all up in their shit. That may be right and
the "mature" way to go, but I'm just feeling too nervous
about this whole thing. I don't know what Carla's
capable of, and I don't want her making any rash
decisions over something stupid I've done.

5:50 pm

Checked for Carla in the linen cage. Nope.

8:15 pm

She wasn't at dinner either. How can someone hide for this long in this place?? It's starting to piss me off... not really. Just worried.

10:23 pm

Well, I've been thinking through your argument—not that you're really making one, but the one I imagine you'd be making. Should this be a time when I recognize someone's boundaries? Or is it okay to blast right over those lines? I know Carla probably doesn't want to see me. And I know she would tell me to go fuck myself. Do I HAVE to listen to that?? What if she's not okay? What if she's done something to herself or if someone else has? Why is it so wrong for me to want to look out for her? Sometimes we need that, even if we don't want it. Fucking shit. Why won't she just let me at least see her to know she's okay? All right. If she doesn't show up by tomorrow, I'm gonna all out hunt her down.

May 30
6:25 am

Swear to god, the minutes are ticking by like hours. I need to get outta this cell so I can find her. I'm feeling like a rat in a cage... times like this make me painfully aware of my moronic call to put myself in here.

9:57 am

I got to breakfast early for once and caught Carla sneaking away with her food, trying to avoid me (and probably everyone else in the cafeteria because of me). When I tried to talk to her, she pulled her ignoring me routine. I didn't want to cause any more of a scene in front of everyone, so I pretended to let her go. Then I followed her. I had to make her at least listen to me. I told her I was sorry and that it just seemed like the best option... the easiest way out for her, and now they'll just let her be. She listened quietly. Then she walked away.

11:32 am

I heard Santos has been basically living in the infirmary, getting every test humanly possible to be sure he's healthy. I heard his two buddies whispering among themselves. They're freaking out too. Santos wasn't the only one who abused Carla, after all. God, it almost made me wish it was true just to see them actually be sick.

1:38 pm

It was starting to feel like she's just gonna stay mad at me forever. So, I had to listen to Leon's in-depth explanation of the M.A.Y. finale at lunch. Just when I was about to shoot my brains out from boredom, Carla walked up with her tray. Before she sat down, she asked if we were too embarrassed to be seen with the diseased whore. Leon told her to sit down and shut up and she did. That was it. Maybe we'll be okay after all.

I know it's weird when all I want is for HIM to be gone and I still find myself thinking about HIM. I was just looking at Carla today and thinking how HE'S so jealous I have a friend, and then I was trying to think of

He'd have to pull some truly shady shit for forever anger. It's hard AF to make friends in here — or anywhere.

[left margin, written vertically:] I spent most of the time hiding out in the commissary. One of the guys who runs it is cool and doesn't mind if I escape there, so he didn't think of it. I never bought anything for himself, so he didn't think of it. Good thing because I needed space from him in a big way.

What else HE'D do to ruin that. It started to make me nervous that HE's tried something... one time, HE did say something like: "What if she knew what you really think of her, huh?" I didn't know what HE meant at the time, but now I'm worried that HE's slipped some other stuff in here. I know I haven't written anything bad about Carla in here, but ... well, I had to check there and there. I can never really know what else HE's been doing when I'm not looking. I didn't find anything. Guess HE was just trying to make me paranoid. I mean, I think I've seen most of the nonsense scribbles and drawings HE's been annoying me with, and nothing in here seemed new. Carla was watching me, though. She was eying my journal with suspicion. It was like she could read my mind and knew what I was looking for. I don't think she trusts me completely. But that's okay. I wouldn't either.

Is it possible to trust anyone COMPLETELY?

4:12 pm That's a nice fantasy.
Well, that moment of peace didn't last long enough. Carla found me at the prison yard. She pulled me under the bleachers. She said she's mad at me because I'm oblivious or just a major narcissist. She said I sit there and write down everything as if I'm so important, as if my thoughts are worth putting down on paper. But, she says, the problem with me is that I don't ever look outward. I only see things from my perspective and in how they pertain to me. She said if I didn't do that, I'd actually be able to realize how humiliating what I did to her was. She's probably right that I would've felt even worse than her if the tables were turned. She thinks all I could see was what I wanted out of the situation, not what it could do to her. I don't totally agree about that, but I didn't say it. What she's really pissed about is that I didn't even involve her in something that was all about her and her well-being. She feels like I made choices FOR her. And then she left. Just left me with a bunch of shit to ruminate on.

The way he writes it, I was having a hissy fit. Not true. I was right. But he got the point, so that's all that matters, I guess.

5:50 pm

All this introspection around the Hot Carla incident has really got me thinking that it's time. I have to send a letter to Krista. Maybe I'll never hear back. Maybe it'll just be a silent fuck you in return from her, but I have to do it either way. First, I have to apologize. Second, I need her help. So I'm gonna get to work on that. I have to do my best to make it good and honest. Gonna work on a draft tonight.

8:45 pm

I decided it was probably safe to go to church group again. Just to keep up the routine since I feel like it's really working. And it seems to be a safe enough place to pass some time. Kevin was there. He gave me a nod that I pretty much ignored. I don't wanna get on his bad side, but I also don't wanna encourage a friendship.

10:11 pm

Well, maybe I did encourage Kevin or one of the other Jesus freaks, or... I don't even want to think it... could HE have taken over again? I know, I doubt it. I've been crazy strict. But I found this cheesy religious pamphlet (I stuck it in here for you to see) sitting on my desk when I came back to my cell tonight. You don't think HE...? NO. Okay, I gotta stop doing this to myself. It's too easy to spiral. It was probably Kevin or someone trying to lure me deeper into the Christian nerd herd.

So, anyway, the letter for Krista. Gonna hash out a rough draft here and see how it sounds.

Don't get me wrong, the Bible brigade are crazies, but I've never seen a pamphlet like this from them. Just saying — this is off.

There's my doodle back at you

Dear Krista,

I'm not sure exactly how to start this letter. I could be all phony and tell you everything you wanna hear, but that was the old me. As you know, I'm away for a while because of that Lenny Shannon thing. It was my choice to be here, and I've had some time to think on things in a way that I think you'll approve of. But here's the deal. I'm not sorry for wanting to help you... did I do it in the wrong way that probably has me on your bad side? Most likely, I get that, and that's what I'm sorry for. I didn't want to let that guy hurt you, but I know what I did ended up doing just that. It wasn't cool of me to invade your privacy, and I can promise you that I'm working very hard to change those ways.

I know you're putting yourself out there to even be helping crazies like me, and I don't want you to think I took advantage of that – even though I guess I did.

Which brings me back to why I'm away. I chose to be here. I'm sure you heard that I had the chance to avoid this, but I went ahead and took the full punishment for my actions. ~~I think that Lenny guy was pretty happy.~~ It seemed like the best way for me to really deal with my problems. I went ahead and took the opportunity to hole myself up and away from everyone and everything for a while to sort myself out. I've been trying really hard to get it straight for a change, and I actually mean that. I hope you believe me because I have something to ask. You can say no, or fuck you, or whatever you feel like, and I know I have no right to ask you for a single thing after

you see that? HE's making fun of me. That I can take. HE can tease me all HE wants, because it makes me stronger knowing HE's threatened by me trying to contact Krista. HE doesn't want her helping me even a little bit. What I have that HE doesn't is the ability to ask for help. HE only has me and HIS doodles and snide remarks, so all I've got for him is THIS.

What I did. BUT, if you still mean what you said about believing I can change and that you can help me do it, I'd like to try again. We can start with a totally clean slate and with me completely on board. I'm not saying it'll be easy and I'm definitely not saying I'll always be cooperative, but I will promise that I'll try as best I can. And I can promise that I do want to be honest with you. I'll shake on that.

~~So, yeah, I guess that's all I've got.~~ So, I hope it's not too much for me to ask, and if it is, I get it. If not, you can write me back here and let me know what you think. Either way, I hope you accept my apology and hope everything's going well for you!

~~Sincerely~~

~~Your friend~~

—Elliot

So, anyway, that's the rough gist. I'm gonna rewrite it and actually attempt at having penmanship that doesn't scream serial killer and send it off tomorrow.

May 31
6:30 am

Maybe things are turning around. It's almost... peaceful around here. Especially with HIM out of the picture. (Of course, when that's the case I always have an uneasy, sneaking feeling that something's about to blow up.)

TICK... TICK... TICK... TICK...

9:46 am

I noticed Carla's been reading a lot of Virginia Woolf lately. I hope she doesn't have offing herself on the brain. I think she's tougher than that, but you never really can know, right? Especially in here. You could say it's none of my business, of course, but I'm worried about her. She's on A Room of One's Own right now. I think that one's pretty mild, though heavy on women's lib, which I'm all for and Carla probably needs. In my awkward attempt to check in with her at breakfast, I said, "Virginia Woolf? You searching for just the right heavy stone?" I know, not the smoothest.

Oh, I officially mailed my letter to Krista. It's done. It's out there and now, we wait. Do you think she'll take me back on? I know I'm ~~too~~ a lot to take, but I hope so.

11:43 am

Still stuck on latrines. I think this is gonna go on for a while, so I better just accept it. The only positive is that it keeps me away from Santos and his guys. I think they're staying away because of Kevin. I just hope they do the same for Carla now that they think she's "diseased."

1:47 pm

Leon says he's going to start watching Seinfeld. Now this is some commentary I'm going to want to hear. So curious what he's gonna make of it. Carla said she's never seen it either and maybe she'll watch some with him. I don't know how it's possible that neither of them have seen a single Seinfeld episode. If you've had a TV in the past 10 years and it's had any form of reception, it's impossible.

He made fun of me, saying I was probably "wasting" my time watching Friends. So not a waste! I LOVE Friends!

I DON'T HOPE SO. HE DOESN'T NEED ANYONE ELSE NEEDLING IN HIS BRAIN. WE'RE ALL FULL UP ON CRAZY IN HERE, KRISTA, SO FUCK OFF.

Definitely not smooth. He can be so dramatic sometimes. Can't a girl just read her book?

4.19 pm

So, I avoided the bleachers today because Santos and his guys were watching the game. I hung out with Carla instead. We just walked laps around the yard. At first, we didn't talk at all. It sort of reminded me of when I was in elementary school and kids who were "boyfriend and girlfriend" would walk around the track. It was so dumb, one of those stupid things kids do when they don't know how to be boyfriends and girlfriends yet. At lunch they would literally just walk laps and probably not talk. I wouldn't know. I never had a girlfriend then.

Anyway, when we're away from other people like this, Carla can take out Reynaldo and he'll hang out in her hand soaking in some rays. Carla finally asked me how I got in here. She said I don't seem like the criminal type. Then she took that back and said I did have devious eyes, so she wouldn't really put anything past me. I thought that was funny. She's the only one who's ever said that. In fact, most people who are annoying enough to comment on them say I have honest eyes. It's usually cheesy people who say stuff like what your eyes say about you. It wasn't cheesy when Carla said it, though. I kept it simple and told her I was in for hacking. She laughed and said that seems right — nerd crime. Then something hit her and she asked if it was something to do with Five/Nine. I just laughed and said I'm small-time. She looked at me like she didn't buy it, but I took the focus off me and turned the same question around on her. All I could come up with was, "Burning something?" She said, "See! you're a lot brighter than you look." I laughed, even though the joke was terrible. Maybe because the joke was terrible. She asked if I really wanted the story and I said yes, so here it is.

Apparently Carla was at a club a while back in her full-on female wear and some asshole started giving her shit for being a dude. She's not really the confrontational type, so she just tried to keep avoiding him. He wouldn't let up, though, kept finding her throughout the night and embarrassing her. Finally, he took it too far and started groping her, trying to feel around for her dick. Well, she found his first and nailed him hard in it and he went down. She didn't stop there, though. She left the bar and went straight into the parking lot. She'd seen the guy pull up and knew which car was his because it was an obnoxious yellow, tricked-out douchebag sports car — hard to miss. She ripped off a piece of her skirt, stuck it into the fuel tank and lit it on fire. She hid behind a wall and waited for the explosion. Not only did the Magnum totally go sky high, it was parked so close to the car next to it, that one caught fire too. And then the one next to that... 12 cars in total. It was massive. I wish I'd seen it. Well, Carla couldn't pull herself away. Watching all of that go up in flames made her so happy, she didn't even care when the guy came out and spotted her, pointing her out to the cops.

Her face lit up as she told me the story. It was a little scary, seeing her go to that faraway place that only she could see. Then she said, "It was worth it." I couldn't help myself, I had to ask her, "Why fire?" She just shrugged and said, "Why not?" I know an evasive answer when I hear one. I took the cue and didn't press her any more. I mean, after all, why hacking? Like a person once told me, ["We all have our obsessions."]

 I liked this day.

5:52 pm

Well, Santos's guys may not be physically attacking me, but one of them came into the bathroom while I was cleaning. He went into a stall and proceeded to take the loudest, loosest, smelliest shit I have ever been forced to experience. I held it in the whole time I was there, but as soon as he left, I puked right in the sink.

7:55 pm

Leon got to the first mention of Art Vandelay... I'd forgotten it happened so early on. He's not really on board yet. I have a feeling he's gonna end up hating it.

JUNE 1

4:16 pm

You may be noticing there's an entry missing from last night and all of this morning. Don't worry. It wasn't HIM. It was Carla.

She found me in the library last night. She seemed sort of annoyed by me. And I say that because she said she was annoyed by me. Well, not at first. She started off by being such a girl. She slammed her book down on the table loudly to get my attention and then started turning the pages. Hard. Finally, I asked her what was wrong. And what do you think she said? "Nothing." Of course. So I wasn't taking the bait. I just kept on reading. So she flapped her pages some more. Then she eyed my journal sitting on the table between us. She asked why I'm always writing in there. I said it just seemed like a good thing to do. She said she didn't like it. Said she feels like I'm writing about her in there. She asked if I do. I said sometimes. Before I could even react, she grabbed it and left. I tried to

chase her out, but she's good in a chase and she disappeared. I looked everywhere for her, but she totally vanished.

I went to her cell and was hovering around, waiting. She had to come back there eventually. It got dangerously close to lights-out and she still wasn't back. I had to give up and go to my cell or else I'd get in trouble. I gotta be honest. I was totally freaking out. I was so worried she was reading everything. I wasn't the only one. Because of this extreme emergency, HE showed back up. I mean, HE was going insane, full of "I told you so's" and "We can't trust anyone but each other" kind of shit. It wasn't helping my nerves at all. It's always even more disconcerting to actually agree with HIM.

Morning rolled around and nothing. No Carla at breakfast. No Carla at lunch. Leon hadn't seen her. I mean, shit, I was starting to think she'd taken a meeting with a publisher at this point. It's a horrible feeling to know all of your secret thoughts could be out there, just lying bare for someone to read and judge. I mean, you know me, so you get it. My paranoia is reaching all-time highs. It was stupid to write in this thing. I used to be the guy who never recorded anything, no traces left behind, invisible. Now I am a fucking autobiographer. Why the fuck did I do this???

Then, HE decided this was the perfect time to chime in again about how HE told me I have the worst judgment about people and I should've never gotten involved with her. She's bad news. HE went on what felt like an hour-long rant about how she's probably turning us ~~in~~ in right now. And who knows how some of the stuff I wrote can seem to an outsider. HE said I definitely look insane and most likely look guilty. I started to worry that HE might be right. I had to take stock of how well I really knew her. I kept asking myself: Would she do that? Could she just betray me? Maybe if she got a deal

I've had my doubts about making this journal public, and this entry sorta makes me feel guilty about it. His fear of being exposed — even just to me — was very intense. So I worried it might not be fair to let you all in on things too. But keep reading and you'll see why I still did it anyway.

out of it. After all, it's hard to say no to that almighty invisible hand. It's part of their power and control over us. But is this my narcissism all over again? Who gives a shit about my thoughts? Would people really spend any money to read it? Anyway, I probably wouldn't blame her if she explored her options at least. The doubt was creeping in like a worm, and HE decided to take matters into HIS own hands.

HE flagged down a guard and told her HE had concerns about Carla's safety. I tried to stop HIM, but HE was able to get out that HE was worried she was going to hurt herself. The guard radioed it in and they set out on a search for Carla. Though I know she's gonna be pissed, I'm sorta glad HE did. that. I really needed to find her and my journal.

FINALLY, she found me in the yard. Though she was coming to me pissed off for being tracked down by the guards and put through a bunch of shit to convince them she wasn't suicidal, she saw I was also pissed and chilled out. At this point, I was coming up with all kinds of crazy shit about what she was doing with this thing and trying to go page by page remembering what all I'd said. I think she could tell she'd taken it too far when I shoved her, asking where it was. I wasn't fucking around. She said it was someplace safe and led me inside.

We went into the library and she took me to a very tiny and very dusty area of books on electromagnetic field theory. She pulled out a super thick book and opened it. Inside was my journal and I snatched it back from her faster than any explanation she could give. I was about to leave when she said she hadn't read it. That stopped me. I wasn't sure I believed her, but she wasn't looking at me like she knew the crazy in my mind, so I thought it might be true. Then she said she hadn't read it because she didn't feel like it was her place. Well, she said she read the first page and then stopped.

She didn't feel right invading my privacy without me letting her and she was sorry she took it. She also said she was even more sorry that I don't feel like I can tell her things like she tells me. I know none of my friendships are a two-way street in the opening-up department, and that keeps coming up. One of these days I might actually have to try it. One of these days... but not today. Even though it might end it with Carla. She said she doesn't like being left hanging in the breeze, being the only one who's putting it out there. She's over that kinda shit and people who are too closed off, so she's not gonna waste her time with me anymore.

Before she left, she told me I should protect my journal better and that it's not good to have something that's that important to me so easy to steal. I looked at the book in her hand and asked her why electromagnetic field theory. She slammed the book closed and put it back on the shelf, saying that A.) she knew it was safe from anyone there—not too many of these morons attempting to study that anytime soon—and B.) she likes the idea of it even if she doesn't understand it.

7:45 pm
Now that I've recovered from my panic, I can look on this whole journal-stealing thing with a little more clarity. She wanted to force me to let her know me, but she realized that's not the way. You can't force someone to be close to you. But how do I force myself out of this impenetrable box I create around me? It's not doing me any favors. Especially when my closest friend is that imaginary mother fucker who is pretty much my enemy 99% of the time. And you. But I'm not even talking to you at the moment. That's how dire this shit is.

HE ISN'T LISTENING TO ME, SO I HAVE TO TELL THIS TO YOU. WHAT MAKES HIM THINK HE CAN TRUST HER? LIKE SHE'S GOING TO TELL HIM THE TRUTH ABOUT ANYTHING! DOES HE NOT REALIZE HE IS IN JAIL? ALL THE ASSHOLES IN HERE ARE LIARS AND CRIMINALS. SHE'S GONNA TELL HIM WHATEVER HE WANTS TO HEAR AND HE'S GONNA EAT IT UP BECAUSE HE HAS A BLIND SPOT FOR HER. AND SHE KNOWS IT. SHE'S GONNA FUCK HIM OVER JUST LIKE EVERYONE ELSE ALWAYS DOES, AND I'LL BE LEFT TO PICK UP THE PIECES. AGAIN. AND I'M WARNING YOU AND HIM FOR THE LAST TIME. END THIS OR THIS WILL NOT BE PRETTY.

He doesn't trust anyone... not that I'm saying I do either. But, in this case, I'm pretty sure she's been solid with me so far. No one's asking HIM to hold my hand. If I get fucked, I get fucked. I'll own it. Anyway, it's not like I'm taking the bait from her. I'm just not there yet. No one needs to be in the inner circle of this crazy.

10:22 pm
So very unlike me, but I took a second to think about things from Carla's perspective. It was bugging me because I was thinking there was something more to her aggravation when she stole the journal, and I'm pretty sure some of her anger was coming from stuff inside her, not just about me. I realized that the way she felt thinking I was writing stuff about her was the same way I was feeling about her reading what I was writing about myself. I think we're both so used to being misunderstood we don't give anyone else the chance to even try to understand anymore.

HE came by. HE couldn't believe I was actually empathizing with Carla and that I wasn't more pissed at her. HE wanted me to stop thinking about her, cut it off, destroy the relationship— HE kept saying, "WAKE THE FUCK UP!" But all I kept telling him back was that my eyes are wide fucking open.

HE didn't like that too much. But then again, what HE doesn't like is probably a good thing for me. Maybe I should do what she wants. Can I ever really do that? Once someone knows the whole me, will they actually still want to know me??

June 2
3:47 am

I'm up. It's fucking dark... I feel like I hear breathing in every corner around me... can you hear that? HE's ready to pounce... any second... HE's there... always there... always... there... SHIT. HE's got my head seriously fucked. HE tried on a new tactic for size. Stabbing. Fucking vicious, psycho-killer, body-slicing-up, blade-to-the-fucking-gut STABBING. While I was sleeping... it still burns... okay, gonna keep writing... it's helping with... the pain. I'll get it all down clearly — everything that happened.

While I was sleeping HE jumped on top of me and repeatedly stabbed me in the gut with a shiv. I think it was seven times... ten? I lost count. It was like I was paralized and all I could feel was searing pain... each stab was like another hot poker digging into all my insides. My hands are still shaking... Hope you can read this. I guess if HE can't get through to me with HIS verbal arguments and HE can't take over anymore, thanks to the routine, HE's gonna go with all-out physical attacks. Despite what I'm trying really hard to convince myself of rationally, it's fucking terrifying. Just trying to ground myself and write my way back to reality and calm the fuck down. I mean, I know HE's not really stabbing me... but it felt fucking real. The longer I keep writing, the less real it feels. It's helping... some... I think I'm gonna throw up

6:37 am

I couldn't go back to sleep. I tried everything. Breathing methods, shutting my eyes, counting fucking sheep... which, by the way, is the dumbest idea for trying to get some sleep. Whoever came up with that shit should be shot. Okay, maybe that's extreme, but that's how fucking rattled I am. I am sentencing idiots to death. That's the place where I'm at.

I know, YOU can see it... YOU know the reality that this is actually still just in my head. And YOU can see clearly that HIS thought process is pretty simple: Torture me until I see reason. Like I said, HE's threatened by Carla, so now HE's stepping things up.

But... what you might not understand, friend, is that until I can shift my reality, it really fucking hurts. Bad. Just as if my stomach is actually bleeding out from every single jab. [THE PAIN IS REAL.] I don't know if HE's gonna do it again, but if HE does, will one of those times actually be real? That's HIS upper hand. I can't know until I'm still able to take that first breath after the attack whether HE's decided to end me or not. This... is new. HE's inventing new ways of torturing me. So I gotta invent new ways of defending myself. And I will ... I will ... trust me, friend ... you trust me, right? I hope you do, because right now I feel pretty fucking unsure about this ... about anything ...

9:47 am

Tried to just get back to normal, to forget what happened with HIM. But there is no going back and my new normal is a constant fear for my life. Constant. Still, I'm trying. I went back to my "being present tools," and I worked really hard to focus on every single word Leon said to keep me sane.

Leon said he saw Santos in the library last night. He said he goes in there a lot to check out medical books — the hypochondria issue rears its ugly head. It's kinda the gift that keeps on giving. He was asking Leon if a rash on his arm looked like scabies. Leon said yes and made up this whole story about how his ~~was~~ aunt had scabies and she didn't treat it and she just kept scratching and scratching, and when you do that, they lay more eggs, burrowing deep into your skin. You get like whole farms of scabies and scabies babies cropping up all over your body and making themselves at home. He 100% freaked Santos the fuck out. I saw him itching and itching all through breakfast. I asked Leon if that really happened to his aunt and he said, "Hell no, cuz. You think anyone in my family's that nasty?"

I love this. Wish he really was one giant scabies metropolis.

11:41 am

Back to my attempt at keeping it together. I was trying to zone out by counting every stroke while cleaning the bathroom. It was working, but then Carla came in. Since she's still cut me off, she turned around to leave, but I stopped her, saying we didn't have to talk but we could at least be in the same space at the same time. I guess she could hear I let a little annoyance into my voice because she got kinda angry and said it was hard ignoring me when I'm EVERYWHERE. She got real dramatic, stretching out her "everywhere," which annoyed me even more — like I'm some stalker leech (I have fucking latrine duty because I was trying to help her). I could tell some of her anger was like embarrassed angry, which made me want to give in and leave even less. If she doesn't want to be my friend, then her feelings aren't my problem. I'm not sure, but I think I almost saw her get teary when I basically told her that, but she cut out of there before I could really tell. What I did see for sure was that she had something behind her back — her electric razor. I think she

Was embarrassed for me to see her shaving her face. I didn't realize that was such a big deal to her and I felt bad for giving her shit. Some other guys came in around then and I had to get back to work.

Just as I was thinking that it's fucked up that Carla probably can't get the hormones and shit she needs in here to, you know, be who she really is, HE showed up out of fucking nowhere and **SHOT ME IN THE FUCKING HEAD**. I fell back into the toilet (thank god I'd already cleaned it) from the impact. I looked up and my brains were splattered all chunky and disgusting against the wall. I was almost too scared to do it, but I finally reached my hand to the back of my head and felt the gaping exit wound. I don't think it's possible to explain to you how fucking <u>bizarre</u> and <u>horrifying</u> it is to simultaneously be feeling where your brains were blown out of your own head and looking at them sprayed on the wall. I could even smell that metallic blood smell. I got cold all over and started shaking. The only thing that brought me back was hearing the laughter of the guys who'd come into the bathroom. They saw me fall ass first into the toilet and freak the fuck out, so I'm sure that was pretty entertaining for them. Somehow I managed to pull myself outta there and took off.

Imagine looking at your own brains like this:

I can't stop shaking. I'm not going to lunch. I gotta stay locked up in my cell. I can't stop shaking. My mind's racing. I can't stop shaking. It's like my whole system is in full shutdown mode. I just got SHOT in the fucking head. How the fuck am I supposed to recover from that?? HOW does someone deal with this shit?!

5:47 pm
Fuck it. I'm just making it a rule that as long as I'm on latrine duty, I'm not gonna write about it. I can't live it over again by writing anything down about it. All I'm gonna say is I really didn't want to go back in there after this morning, but thanks to the goddamn regimen and rules of this fucking institution, there I was, back in the stall where my brains were previously sliming down the wall. Not good... am I losing it? yes, yes, I'm losing it. I'm fucked.

8:15 pm
I managed to think straight for a second and I saw it all clearly! HE wants me to get so panicked and paranoid that I give up the regimen and distance myself from people, right? So I gotta do the opposite. Always the opposite of what HE wants. So I forced myself to go to dinner. It's back to just Leon and me again. I miss having Carla around. Anyway, I was looking at the Tyrell sightings for the day (more to give myself an excuse not to talk than really caring where he's been "seen" lately). While Leon was explaining that he's taking a break from Seinfeld. He's having trouble getting into it. Out of nowhere, he asked why I always read the sightings. He wanted to know why I'm so interested. I asked why he isn't so interested and he said that's not an answer. He got me there. I needed to come up with something convincing, so I just gave my default

"I don't know" shrug. I tried to keep going with "We all have cheap guilty pleasures, don't we?" I mean, after all, isn't there a whole industry of gossip rags and reality shows created specifically to feed the basest instincts of mankind's worst desires? Leon called bullshit on that immediately. HE decided to show up and jump in to fuck with me some more. I jumped, literally. HIS presence now scares the fuck out of me. HE was egging me on, saying, "Yeah, why are you so obsessed with Tyrell, huh? I've been asking you the same thing for weeks. Who cares where he is? Is that what this whole thing's about? Why we're here? Because you just HAVE to know where the hell that Swedish fuck is? LET IT GO!" HE just kept coming at me like that until finally I just said, "I'm just looking for one that makes sense." Then Leon asked how I would know, so I admitted that I'd met him. Yep, I went one step too far and that got him oh-so-interested! But this I didn't have to lie about. I just gave him the boring version about how I worked at Allsafe and he came in sometimes. That he said some stupid shit about my desktop environment and that was it. I think he was disappointed but at least that satisfied his curiosity.

That whole interaction got me thinking, though. In the chaotic mess that's been my life in here, I've sorta lost my bearings a bit and, despite my best efforts, I've somehow ended up with a friend when I was trying to keep it solo. Have I made a mistake? Have I opened myself up too much to Leon? Maybe I'm being overly paranoid and he doesn't really know all that much about me or... am I not being paranoid enough?

10:30pm
HE had no trouble chiming in about all of the above questions, and I'm pretty sure you know where HE stands on things. The thing is, I just really can't know the right answer. That's what trust is, I guess. You just cross your fingers and hope you've made the right educated guess.

Guess you can teach an old dog after all. (He'd probably say that was one of my bad jokes, but he is much, much older than me... ☺)

It takes some time to weigh the pros and cons, but in the end, you just have to grab something and jump. I will admit that it sometimes is nice to have HIM to talk to about things when HE's not being totally insane. It's sort of like dealing with a kid who only has a vague grasp on the idea that the world doesn't revolve around them. You can't totally blame them for it because they've operated that way their whole lives. I wish HE would drop this Mortal Kombat bullshit and grow the fuck up. It's kinda hard not having ~~either~~ either of you to talk to these days.

June 3
6:32 am

I don't know why Tyrell keeps popping up in my dreams, but he did it again. I guess it was all the talk about him last night. It's pretty obvious, actually, 'cause he and I were walking along the Great Wall in China. That was one of The sightings in the paper last night. The weird thing was that we walked for what felt like a really, really long time and then I lost him. I tried to catch up to him, but I couldn't. I couldn't walk fast enough. Then, all of a sudden, W.R. walked up beside me. She was pissed that I made her wait... for what? I have no idea. It really made me feel kinda worried that she was so mad at me. I don't want to be on her bad side, and I know she's got dangerous ideas on payback. I went to apologize, but when I looked up, she was gone. It left me with a strange sensation when I woke up. Can't quite shake it.

I wonder if I'll hear back from Krista. If I do, and if she does want to see me again, I'm going to ask her about some of these dreams. Well, maybe I won't go too into specifics about who's in them, but maybe there is something to the meaning of it all. I dunno, I clearly have a TON of shit to talk to her about.

Maybe HE'LL have the incentive to stop fucking attacking me if HE knows it's gonna push me to tell Krista about HIM. I hope HE's hearing/reading that too. HE can shoot and stab me all he likes, and as horrific as it is, I won't give up. I won't—

HE LIKES TO THREATEN THAT. TURNING ME IN. TURNING US IN. ADMITTING EVERYTHING. COMING CLEAN, BLAH, BLAH, BLAH. BUT HE DOESN'T HAVE THE BALLS. HE KNOWS IT'S SUICIDE. HE CAN'T KILL ME WITHOUT KILLING HIMSELF. I AM A PART OF WHO HE IS. I LIKE TO THINK THE BETTER PART, BUT NO NEED TO SPLIT HAIRS. ANYWAY, THIS KID'S GOTTA GET A GRIP ON REALITY... AND IF IT TAKES ME FUCKING WITH HIS ILLUSIONS TO GET HIM THERE, I'M MORE THAN HAPPY TO PLAY.

As soon as HE gave me the book back, HE took the pencil and slit my throat with it. I couldn't stop coughing, but I also couldn't cough... no air... just writing it again is giving me a panic attack. That feeling of trying to suck in air but nothing coming in is so paralyzing. It's like something's wrong and not working and your mind says it can't be right, but it's true... you can't breathe. The realization hits and it's just...

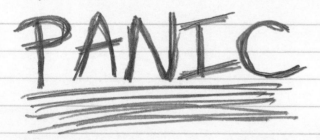

PANIC

I can't do this... there was blood squirting all over this page. Do you see it? Is it still there?? <u>FUCK</u>. Look, I know I'm crazy, but... am I? Maybe you are. I can't grab on to the real of it... and it's driving me crazier. Do you know what it's like to feel like you're dying every day of your life? I can't go on, I'll go on.

I tried analyzing this one, but I've got NO idea what it means. Not sure who W.R. is?

I'm very positive we did not get a tomato juice option. Poor Elliot.

Forced myself to breakfast. I nearly threw up when I saw Leon was drinking tomato juice. It's so thick... like blood. I didn't even know we had it in here. Do we? Was he really drinking that or did I...? Whatever. Focus. Carla wasn't there. Leon said she had to go get her wrist looked at in the infirmary. I decided to take my mind off things by focusing on Carla. Maybe we're all in transition, just like her, hoping one day to reach a destination that's free of our past nightmares so we can live happily ever after in our future fairytale. That's right, that's the ticket, stay positive. Maybe help Carla reach her destination, maybe that'll distract and ~~and~~ inspire simultaneously. What an awesome solution to being shot in the head every fucking day. I asked Leon if he knows anything about Carla's hormone situation. He said she could probably get what she needs in here, but none of the higher-ups bother to help her out. They pretty much don't acknowledge her situation at all. I asked him why she ended up here instead of a woman's prison. He said it's still hit-or-miss on if they consider someone like her a woman these days — it's still a controversial issue, and some places just haven't evolved yet. That really pissed me off since I've seen firsthand what happens to her around here. So I asked Leon to see if he has any way to help get the hormones she needs. I know it's a long shot, and he told me as much. He said he'll see what he can do, though it just might take some time. I told him to do what he's gotta do and if he finds out it's possible he should let Carla know. He should keep me out of it because I don't want her knowing I was involved and it's not my business anyway. Whatever gets worked out is just between them.

These guys are two nosy, conspiring fucks!

11:34 am

I'm still losing it. I can't go a second without picturing my brains all over the wall. I overheard Santos talking to his buddies in the bathroom while I was mopping. Guess Santos got a clean bill of health — as if he deserves that. He's thanking his lucky stars, but at least he's gonna stay away from Carla. Then he got a call from his wife on his cell phone and started talking all lovey-dovey to her. He may not be infected, but he's fucking sick. It's always the worst shitheads that seem to fucking coast by, while I'm getting shot every day by my imaginary whatever the fuck. Look, I'm not gonna fixate on it, but... well... why the fuck not? Why doesn't anyone try to fucking hold people like Santos accountable? Are we that apathetic? We just all turn a blind eye while bullies bully their way to whatever they want?

Speaking of ... HE's keeping his distance ... just making HIS grand appearances to fuck with me. As much as I'm trying to deal with it, I'm always looking over my shoulder like a paranoid freak. I'm tense as fuck. Yup. I'm still losing it. What happens when it is officially lost?

1:51 pm
Carla was back at lunch, sitting a few seats away. She seemed upset, probably because that fucking wrist injury is just a reminder of all the bad shit she has to take in here. All I could do was sit quietly, staring at her healing wrist, fantasizing about how Santos is enjoying fucking his wife, enjoying getting away with being a shithead, enjoying his life that I allowed him to have. And my brains on the wall. I'm still fantasizing about that too. Rather, haunted by it. But I squeezed my table, held it all in. I can do that well.

4:12 pm

I saw Santos glaring (or was it leering?) at Carla in the yard. Now in my fantasy about my brains on the wall, they've turned into his brains. My jitteriness has turned into spite, all aimed at Santos. The lucky motherfucker is getting a lot of my attention, I've transformed all my nerve-racking and shaking into pure anger. Probably not healthy for me. Definitely not healthy for Santos.

8:15 pm

HE attacked me again. I'm not even going to write down what HE did. Maybe not giving HIM that satisfaction will burn HIM just a little. HIS actions aren't enough for me to put in print.

Should I give up? These attacks are so strong, so... fucking INTENSE. It makes me feel like everything else I'm doing is pointless. Unless... well... maybe I just have to accept them... NORMALIZE them. Maybe I can make them a part of my day... as if they are just part of the regimen as something that's gonna pop up every day? A bullet to the head along with my bacon and eggs. A knife in the gut along with my Diet Coke and Big Mac. I'm trying to make light of it, that's how I can tell I'm really fucking scared this time.

10:17 pm

I don't have— FUCK! This entry was just interrupted by HIS response to my above question. What HE had to say was: "Normalize this" as HE fucking cut off my fingers while I was writing. I jumped and fucking fell back out of my chair, and for a second I completely stopped breathing. BUT I've been thinking about that normalizing thing ever since I wrote it earlier, so it sorta clicked and the idea helped. It was like I was ready and expecting an attack and I wasn't as shocked. Let me be totally clear,

it wasn't like it didn't fucking hurt like hell and didn't scare the fuck out of me, but I was able to calm down faster. A small positive step, even though at the moment I'm watching blood pour out of my jaggedly cut digits.

June 4
6:20 am

I hate everything. Yeah, I'm a goddamn yo-yo and don't think I don't see it. Last night I was feeling a tenth better, but today I'm fucked. These surprise attacks are working despite my very, very minor victory last night. And who am I kidding? That still freaked me the fuck out. I know I let HIM win... but what can I do? I can't get a fucking grip. There's nothing and no one around me that I can grab on to to keep me from falling...
 falling...
 falling.........

9:37 am

|Anger.| It's the only way out of this. I just sat and stared at Santos all during breakfast. Letting my anger ferment into a plan of attack. At one point I think he saw me glaring and I'm pretty fucking sure he winked at me. Self-satisfied piece of shit. All I could think of was how upset Carla was at lunch yesterday. And my bloody digits. That fucking loser really fucked her up. He's wrecked her life and just sits there shoving down loads of biscuits and gravy like it's any old average Wednesday. And HE, well, I can't punch-hurt HIM. Not yet, anyway. MOTHERFUCKER. So it'll have to be Santos. He's what's wrong with the world and... he needs to pay.

HE showed up, but all HE had to say was Santos isn't the answer. Of course he isn't, getting rid of HIM is the answer. But Santos will have to do until I can figure it out.

11:47 am

Shit. I don't even... I don't know what... okay, I'm totally fucked in more ways than one. When I was in the bathroom doing duty, I was cleaning out one of the toilets. Someone came up behind me — you know how I said you can't really know or hear what's going on around you when you're inside one of those stalls — anyway, they came up all silent, so I didn't hear a thing before I even realized they were there, they shoved my head deep down into the toilet bowl and flushed it. I couldn't breathe, I was drowning. It was so fucking scary. They just kept holding me down, never letting up, and I took in gulps of water. And we're not talking the clear kind. We're talking shit-brown water. With clumps of shit floating around. We're talking a smell of urine that's strong enough to fight its way through that overpowering stench of shit. Then, all of a sudden, they just let go. I threw myself back against the stall wall, gasping for air and throwing up all at the same time. By the time I looked around, they were gone. There was no one there at all.

What has me ass backwards is I don't know who it was. Was it Santos's men? Did they figure me out? Was I staring at him too long during breakfast? I haven't lost any time — I couldn't have, right? No chance for HIM to warn Santos, right? Right? Or... was it HIM just messing with me again? Is HE trying to prove HIS point or stop me from making my move on Santos? Either way, I just want to sit right here and be alone. But the more I'm alone, the more I think. And the more I think, the more I wonder: Do I even know what's real anymore? Does HE have me so twisted that I wouldn't even know if Santos and his guys did actually shoot me for real? Could I actually die and not even know it was really happening? Would I just believe it was HIM coming at me again and any blackness of death I'd fall into I'd just think was HIM taking over? Or is it the opposite? Am I really so hyperaware right now

that if I were finally attacked for real, would it be so intense, so brutal, because every fiber of my being is heightened and ready and feeling every little thing that there would be no mistaking the real thing?

3:56pm

Skipped lunch. Tried to just block myself off and be alone, but there's no chance of being alone around here with HIM on the loose. HE just loves any moment HE can creep in and go for the jugular... literally. HE snuck up on me when I was trying to read (and by read I mean reread the same page over and over because I can't concentrate) to get my mind off things and HE shot me in the fucking neck. I haven't been able to stop the blood gushing from the side of my neck yet. Hopefully it'll stop. It's hard to stay calm when that is happening. It's hard to even write in this journal when there's a red waterfall coming out of where my vocal cords used to be.

5:57pm

It was almost too easy. There I was, minding my business and scrubbing away at caked shit stains, and in came the biggest shit stain of them all— Santos. Not much later, though, Lone Star came in and frisked everyone in the bathroom, including me. He found a decent amount of joints and dirty magazines, but the worst violation was... you guessed it... Santos's contraband phone. Straight to the SHU for Santos. And come on... you think he's gonna know who to blame? Even if it was me who slipped an anonymous note to Lone Star saying some serious drug deals are going on in the bathroom? I made the point of saying it was drug deals since that doesn't point directly to Santos's phone. I think Lone Star was stoked to find the phone, actually — it was a total bonus catch for him that he'll get extra brownie points for. Anyway, I was in the fucking lineup too, which will also help my

cause with shifting the blame. He might be bright enough to figure it out... to even remember I was there, but he had a lot going on and, really, no he's not that bright. Doesn't really matter to me. Finally... that asshole got what he's had coming. I feel a little better. Hate is always a great distracter.

NO SHIT HE'S GONNA BLAME YOU. HE'S DONE IT EVERY TIME BEFORE, AND YOU HAPPEN TO BE PRESENT YET AGAIN? FOR FUCK'S SAKE. YOU BETTER WATCH YOUR BACK, KID. HE'LL BE COMING FOR YOU QUICK. YOU WANT ME WITH YOU OR AGAINST YOU WHEN HE DOES? THINK ABOUT THAT!

I almost think HE likes hearing that I could be in danger again and again and could need HIM. Maybe HE'LL even rat me out to Santos again out of fucking spite. Maybe HE already did and brought on the bathroom attack. But I don't think so. HE hasn't been able to take over for a while now— that, I AM in control of. So, HE can hear this... I. DON'T. NEED. YOU.

JUST
SAY NO
TO ROBOTS

8:20pm
Carla was super stoked to hear about Santos. At least that's what I overheard from her and Leon talking tonight. That was the cherry on top. She was giving me a real suspicious look when she asked if Leon knew who busted Santos. She knows. She can read me. Whether it turns out good or bad, it definitely felt good to do. Duh. Of course I knew it was him! Didn't take a super sleuth to see that one, though I am very good at reading him. My secret? I see the best in people.

10:30pm
I was still riding the wave tonight. It's like a high where I'm pretty sure I'm still fucked up and the problems are piling up around me, but I don't really care. HE's probably planning HIS next attack, but fuck HIM and fuck Santos. Carla was away

from her cell and I snuck in to visit Reynaldo, who was chilling in the wall behind a loose brick where Carla lets him roam when she's away. I lured him out with a little snack. I think he's officially accepted me — not saying we're friends or anything, just saying the rat's down with me. Yeah, I hear myself... I'm talking about a rat's acceptance. I get it.

June 5

6:35 am

Wide awake. Been this way all night. The high wore off and the terror returned, so I decided to keep myself up all night. My eyes are burning, but at least no one's sneaking up on me. At least my neck isn't bleeding. At least my fingers are still there. At least there isn't a bullet lodged in my brain. This is torture.

9:46 am

I couldn't focus on anything Leon had to say this morning. I'm still frazzled and a little jumpy from yesterday's attacks. I hope both of those were HIM and I don't have Santos's goons on me too. I just told Leon I couldn't sleep and was tired. He looked worried that I kept looking at the seat next to him. It was empty, but I kept waiting for HIM to appear and taunt me. Think it made me look a little like a weirdo.

1:32 pm

Lunch. No sign of HIM.

3:58 pm

I was antsy and couldn't sit still at the game. I think Leon noticed and he tried to blab extra-detailed about Seinfeld (he's back on it, though no less doubtful about its quality). I was grateful for the effort and thankful for the distraction. Distractions are pretty much all I live for nowadays.

5:45 pm

Been thinking about this all day. I'm 99% sure it was HIM who attacked me in the toilet. HE's getting what HE wants, I guess. I'm holed up in here, scared and going out of my mind. Just the cracks HE needs to start worming HIS way back in to get a better grip on me. I have to keep up with the regimen. These are the times to stay strong.

I forced myself through latrine duty. I've made it a little easier by coming up with tricks to make it through. This time I just kept repeating the TGIF lineup, complete with each show's character names in alphabetical order, over and over to keep myself calm.

STEP BY STEP THROUGH THE FAMILY MATTERS OF A

8:03 pm FULL HOUSE OF PERFECT STRANGERS

Dinner was fine. After my repetitive reciting, I couldn't help but keep thinking about the TGIF characters and what would happen if they were all on one giant show together. A super sitcom. Again, the distraction is helping.

DO WHATEVER YOU NEED TO DO TO FEEL BETTER. THAT ONE WASN'T ME. I MEAN, YEAH, THE JUGULAR WAS, BUT NOT THE BATHROOM. WHAT HAPPENED TO YOU IN THERE WAS FUCKED UP, AND I HATED SEEING YOU GO THROUGH THAT. I ALSO HATE SEEING YOU LIKE THIS... AFRAID. I'M HERE FOR YOU, THOUGH... ALWAYS. I DON'T WANT YOU TO GET HURT ANYMORE, ESPECIALLY WHEN IT CAN BE PREVENTED. I JUST WANT TO HELP IF YOU'LL LET ME.

10:21 pm

I really don't have a response to that faux attempt at an emotional outpouring. Especially when I still have some strong feelings that HE was the one responsible for the bathroom attack.... not to mention HE hasn't let up a bit on HIS open strikes against me. How am I supposed to buy that HE's so affected by my pain when HE's the one causing it? Even if it wasn't HIM in that bathroom — Was it? Do you know?

Of course you don't because you aren't fucking here, but maybe it it wasn't? You aren't even reading this right now. Are Santos's guys on to me? Or is HE using multi-pronged attack vectors to turn me all around? I don't fucking know anymore. These Manson love-hate, push-and-pull mind games fucking blow.

June 6
6:30 am

→ Those cult leader tactics do blow, but HE uses them because they work... even on someone as smart as Elliot. All it takes is a little vulnerability.

I don't wanna talk, and I don't wanna get out of bed.

9:59 am
Guess dragging myself to breakfast kinda helps. It's nice to be around Leon. And HE hates that. I even tried to talk to Leon about my problem a bit. But I think I was too chickenshit to get specific enough for him to really understand what I was talking about and I don't think he got it. Tried to relate our plight to something George was going through (sorry, the details are foggy for me now). Maybe he IS catching on to Seinfeld after all. Anyway, even if it brings on yet another assault, I gotta keep trying to communicate with Leon — with anyone — and distancing myself from HIM.

When HE read that, HE just pulled a gun right out of HIS pocket, aimed it at me and shot me in the face. I could feel the burn from the heat of the gun, HE was so close. I could feel my bones shattering. Since I sorta saw it coming, I gripped onto the chair hard to brace myself— like you do when you're about to be in a car accident. I think it helped... a little. I feel like I bounced back quicker. HE could tell too, I think. HE didn't like that. HE did this right in front of Leon, by the way. I know HE thinks HE's being bold, but HE better watch out because they might catch on. And if they do...

1:36 pm

I didn't even notice that Leon had a visitor yesterday. He said his old friend came to visit — I guess it was that Asian girl again.

I caught Carla glancing at me during lunch. She tried to hide it but I caught a hint of worry. Guess I'm not doing a good job of hiding the trauma... I think the bags under my eyes aren't keeping it a secret. I wish I could talk to her. I guess I'm the only one standing in my way.

4:17 pm

He looked like shit. I tried to be like him and not worry about it — focus on myself — but I'm just not as good at i The game was pretty heated today. I guess everyone around here as h is under attack in some way every day. Comes with the is territory, even if you're not crazy. Lone Star had to break up a fight on the court. There are all kinds of sides in here — black, white, Latino, Asian... and they don't really mix. I guess that's not so different from the outside world. I know we like to think we've come so far since we don't make African-Americans drink out of different fountains, but there's still a lotta change to be done. The thing is, we're all different and that's okay. It's okay to say that we're different. Thats where I think some people go off wrong in the PC route. We all <u>deserve</u> the same things, but we aren't all the same. Know what I'm saying? And I'm glad for it too, because if we were all the same, it'd be boring as shit. Not to mention, I don't think the world could handle a bunch of people the same as me. I've already caused enough trouble on my own. I could fill up a few pages on all that (probably already have), but if someone like Kevin were to somehow get his hands on this he'd get my words all screwed up and think we're on the same team with the "White is right" kinda thinking. I honestly think he thinks I'm pure white just like him. <u>It's weird what we can make ourselves believe just because we want it to be true.</u>

A mistake I keep on making.

FUNNY YOU SHOULD SAY THAT. I BELIEVE I SAID SOMETHING SIMILAR TO YOU A WHILE BACK — I.E., YOU CAN'T BELIEVE AWAY THAT I'M NOT HERE. HOW MANY WAYS DO I HAVE TO PROVE IT TO YOU? I WILL SAY ANOTHER THING: YOU'RE DELUDING YOURSELF WITH THIS SANTOS THING. HE'S ALREADY MADE ONE MOVE. WHAT ARE YOU GONNA DO WHEN HE'S OUTTA SHU AND COMES FOR YOU HIMSELF?

> I'll deal with that when it happens.

7:40 pm
I heard back from Krista and she's gonna see me again. Well, she said she wants to meet and see if there's somewhere to go from there. She's feeling me out. That's fine. I'll take it. It's not gonna be for a while, though, and I'm hanging by a thread — alone with all these fucking thoughts and, of course, HIM.

9:15 pm
Went to church group to ... well, I dunno why. Just to do it, I guess. To be around other people, even if they're a buncha assholes. Carla slipped in after me and sat far away on the opposite side of the circle. So she IS definitely worried about me, right? If she followed me in here? She hates church group. Or maybe she didn't follow me and she couldn't give a fuck. Maybe it wasn't about me at all. Either way, it was kinda good to have her there. Just her being there. Sometimes that's all you need, though it gave me an idea ... and HE'S definitely not going to like it ...

As usual, everything revolves around him. But ... he's right, I do hate church group, so make of that what you will ...

10:31 pm

I want to show Carla that, although I'm all those things she said after our Santos blowup, I can be vulnerable. She wanted to know what goes on in this journal and why I think it's so important to write everything down. She wants me to come clean, be open and all that shit? Well, I'm going to show her the truth. THAT is HIS biggest fear... that I expose HIM

ELLIOT, IF YOU DO THIS, I'LL HAVE NO CHOICE BUT TO INTERFERE. AND THAT WILL BE VERY VERY VERY VERY VERY VERY BAD. FOR YOU. AND FOR CUNTY CARLA. NO ONE CAN KNOW YOUR TRUTH. I'M TELLING YOU, ONLY I CAN UNDERSTAND IT ALL. PLEASE LET ME DO WHAT YOU WANT ME TO DO. LET ME PROTECT YOU. TELL HIM. YOU KNOW IT'S TRUE TOO.

Is that true? Tell me once and for all. Do you side with HIM on this? Oh yeah, you can't talk to me right now. This is all on me. After all this time (and you can say I'm slow in figuring this out), I realized why I wanted to know Carla— she and I are the same. It's that simple. I know you can see it. I think it's pretty obvious what she and I have in common and, yeah, I know it was a little dim not to piece together those parallels right off the bat. But, gimme a break, it's harder to see those kinda things about yourself. Just like it's easier to give advice rather than take it. That's what I was doing with Carla all this time and she just let me in. So it's my turn. She coulda read the journal already and she chose not to. Because of that, and pretty much everything she's told me (and a lot of things that she hasn't had to), I trust her. Besides, I can't live like this anymore. I need to tell someone about what's going on. I need someone to understand.

June 7

6:39 am

Didn't sleep well last night. Woke up all sweaty. Had a fucked
up dream. Don't remember much. But it was something to do
with Tyrell... I remember him in a garden, but he was
wearing a suit... digging up vegetables. Angela was there on
a swing, I think, singing... something? Feels like it was a
nursery rhyme. Don't remember it exactly. I was me, but I
was watching another me eating a tomato and listening to
Tyrell. But he was just speaking in numbers. Understood him
about as much as if he'd been speaking in Swedish. Anyway,
Angela was swinging too high and it seemed like Tyrell was
encouraging her to go higher in his numbers-speak. I was
yelling at her to stop and slow down, and just as the rope
on the swing was starting to fray and unwind, I woke
up. I dunno what that means. I know, hearing about
someone else's dreams is THE WORST, so I apologize to
you for that.

By the way, I haven't 100% decided on the Carla situation
yet. I mean, I'm trying... I know, I'm such a pussy.
 I hate myself.

9:39am

Now that I've threatened coming clean with Carla, HE's trying
every last tactic HE can think of to get what HE wants. HE
sees HE has one last sliver of a chance to convince me
not to, so now HE's pulling the nice-guy routine. Apologizing
for all the attacks. HE says HE'll stop... if I just
try and consider getting out of here. HE says ME doesn't
care about me being friends with Carla... HE'll leave
that alone if we can just pack the fuck up and get
back to civilized society. I can't do that. HE knows it.

So I just ate my waffles and listened to Leon talk about the busboy episode of Seinfeld. The one where George can't do anything right to make a bad situation better... I know how he feels. Elliot doesn't know this, but I saw Santos when he got out too. I didn't get a nod. I got a slitting the throat move and a threatening smile.

11:51 am
I'm officially off latrine duty. Thank fucking god. But I have to focus on the regimen more than ever to cope with the bullets and knives. Santos is out of SHU and was back on kitchen duty too. He gave me a weird nod. Sorta like a "We're cool" kinda thing. Guess he didn't think it was me after all...? Maybe that's all finally done.

1:36 pm
HE gave up on the nice treatment (it's definitely not HIS thing) and pulled another attack on me. HE just came out of nowhere and said we make a move to get out of here or HE'LL shoot me. I said I want the truth. So HE shot me right in the heart. For like one minute I thought my life was over. I actually felt my heart burst inside of me. I felt the blood trickle down my internal organs. I started to cry. I missed Darlene and Angela. I wanted to see everyone. I was dead. It was over. But then I looked up and could see HIM, standing in front of me and smiling.

7:43 pm
After that, I hold my heart every now and then. I can sometimes almost feel the terrible pain of a bullet piercing it. Shit. I'm scared. I don't think I can take this.

10:14 pm
I'm doing it.

June 8

7:45 pm

She read it. All of it. Didn't get it back until now. I
have to say that, for someone who reads a lot, she took
a shit ton of time to get through this short thing while
I was on pins and needles. I think she's still processing,
but she doesn't seem mad anymore. She looked at me
differently, but not in a bad way. It was weird, but
I think she understands . . . I think . . . there was
something in her face that said it all. And it felt
good. I mean, I'm sure she has a lotta questions.
Well, she said she did. She said she could ask them
or just drop it, but the best thing she said was . . .
"I know how you feel." That's all I wanted to
hear, I think. I'm glad I will see another sunrise.

10:31 pm

Reynaldo is dead. Santos nailed him to a bathroom stall
with a note that said: "This is what diseased animals get."

I don't have to state the obvious, but Carla is devastated.
When I saw her face . . . it reminded me of Darlene
in the car when she realized Moon Pie was in the sack.
But Darlene was able to save Moon Pie and I . . .
Fuck . . . I just broke Carla's heart.

Poor Carla took Reynaldo down and burned him in her
wheelbarrow. She was crying the whole time but wouldn't
let me close. I don't think we can come back
from this.

It wasn't just what happened to my poor
Reynaldo — it was what it meant.
Santos won.

MAN, YOU ARE STILL LOOKING AT THIS FROM THE WRONG ANGLE, KIDDO. SANTOS IS PISSED AND HE'S GOT YOU ON THE BRAIN. FUCK REYNALDO AND CARLA. NOW SANTOS WANTS MORE FROM YOU THAN A RAT TO NAIL, YOU BETTER SLEEP WITH ONE EYE OPEN FROM HERE ON OUT. BECAUSE LAST SUNRISES WILL BE THE LEAST OF YOUR FEARS AFTER I'M DONE WITH YOU.

See
6/16/15

HE may be right. ... I'm not afraid of Santos, though. My focus remains soley and completely on eradicating the only villain that matters ... HIM. HE tried to take the journal from me to write some more, but I won't let HIM have it. HE's said and done enough. HE's the one who's always looking at the wrong angle of things. It's always hardest to watch someone going along who doesn't know what's about to hit them. Well, I'm ready for it. I'm always prepared, 'cause HE's taught me never to close my eyes ... never to think I'm safe. So ... I'll be on my toes. Dedicated. Driven by one single-minded goal ... to get rid of HIM once and for all. I'll be like starting from the beginning.

Got distracted by the annoying wake-up call and forgot to date this, so here it is: June 9

6:27am
Woke up a few minutes before she yelled, "Time to get up!" I can't decide if I like that wake-up call or not. I guess some days it's okay, and others, well ... it bugs the fucking shit outta me. Don't get me wrong, I know I chose this, but can't a guy just wake up to white noise? God, it's finally happened. I'm a person who wants to listen to white noise to sleep.

9:47 am
Leon just watched the Chinese restaurant episode of Seinfeld. He just can't get his head around it. He doesn't get the metaphor for life, that we all wait for something to happen and it's the waiting that's the thing, not the outcome.

11:53 am

Dishes. I think I know how Newman feels about the mail...
"It just keeps coming and coming and coming!"

1:37 pm

At lunch Leon was going on and on about the parking garage episode
and how it has no story. I don't think I feel a need to
always have a story. Like I said, it's in the waiting, the
anticipation. The end isn't the goal, because that's when
you're fucking dead. Life is just one long middle of moments.

LIFE
— — — — ↓ — — — — —

3:42 pm

Speaking of middle moments, I saw Hot Carla today in the
yard. She's still not speaking to me. I saw her burning
something. I think it was Waiting for Godot—how fitting,
given where we are. She gave me a smile. I thought about
talking to her but didn't. I wonder if she's going to
ever forgive me.

5:39 pm

Okay. I'm definitely going to stop checking in after laundry
and kitchen duty for good. Just makes me depressed about
the monotony, and I gotta stay on board with it.

7:51 pm

It's been a real heavy Seinfeld day for Leon and he's
coming to the thinking that the point is life's pointless.
He's really taking to heart the nihilism angle of it all.

10:21 pm

Obama held a press conference today officially announcing that Tyrell Wellick was in charge of the Five/Nine Hack and there's a manhunt to find him. I can't believe (the one question) I've been struggling with happens to be the same one the entire world is actively trying to answer. I guess that's a good thing? The fact that HE is keeping what happened that night from me means it can't be good news, right? I never can tell with HIM and HE's sticking to HIS vault status. I don't know what HE wants so bad or what plan HE has to get it, but HE doesn't want it bad enough to tell me what happened.

June 10 The question that consumed the world.
6:41 am

So, today's the day. I'm finally seeing Krista. I've got a lot to say and I guess it's now or never. On the other hand... will it just open up a whole new can of worms? I mean, I've just gotten her back on board. But I'm sure she'd get a real hard-on for an even bigger head case to deal with. Don't therapists just eat that shit up? I'm not gonna lie, that might be part of why I've sorta held out this long. I just don't think I can handle that _excited_ face I know she just won't be able to contain at getting a real _wack job_ on her couch. I've seen that face on many
 therapists who've tried to "fix" me.
9:30 am
My nerves were getting to me over breakfast, so I decided to distract myself with Tyrell sightings for the day. Here are the greatest hits:

 — In the Harrods candy section
 — Skiing at the indoor ski slopes in Dubai
 — Playing a round at Torrey Pines—I mean, he's definitely a suit, but golf?? Not sure that's an image I can take.

12:40 pm

Just got back from my session with Krista. HE's here. HE's mad that I'm talking to you. HE wants to get to work. Something about Che Guevara throwing up. I'm trying not to listen————

HE shot me in the head again. I didn't panic like last time— I stayed calm. HE also said that control is an illusion? By the way, I'm talking to you again. I'm still not 100% on you, so I'm holding back a little when we talk. Don't worry, in here I'll tell it to you like it is. As for the talking, I'm gonna let you gain back my trust little by little. I didn't let you in on what went down with Krista, so here's some of it.

It was weird during our session with a bunch of other people around. Not exactly the ideal patient-therapist scenario for opening up and getting touchy-feely, but I've chosen to be here, so I have to just work with it. We had to talk a bit about how she's agreed to still see me even after my "destructive, violating, and unhealthy lack of boundaries." Despite that, she's still on the fix-Elliot train. Guess some people are cursed with the eternal optimism that they can change people.

It's just easier for me to talk out loud about things as I'm living them, so I just went ahead with my world as I'm seeing it. That means I was talking to her like I'm at my mom's. She went along with it. I mean, I noticed her reaction to it, but she hid it pretty well and just let me have it. I guess she's used to talking to crazy people who think they're living on Mars. I'm sure we'll have to have a big talk on it at some point.

Okay, so now the big stuff. I decided to tell her about HIM.
She was pretty floored. The hard thing is that I don't have a
lot of answers to her questions. I don't remember how it all
started with HIM, but she said that's not unusual. I mean,
she was really easing in, not poking around too much yet.
I promised her I'm gonna be honest, though. We made a
deal and I mean it. Anyway, I couldn't really tell her
when HE first came around. There was that time with
Darlene at Halloween that I could tell something else
was going on deep down, but I didn't actually see HIM
then. And then there was nothing until I first saw
HIM on the train that day. I also told her about that
time when my dad pushed me out the window. She wrote
a lot of that down. So anyway, I guess it's out there
now and seems like we'll be digging into it from here on
out. Great.

3:45 pm
Tried focusing on the game, but my mind's still reeling
from spilling it all to Krista (or maybe it was from getting
my brains blown out again). Dealer's choice.

5:43 pm
I have a fucking intense headache. Maybe it's a migraine?
I've never had one. Feels like my brain is splitting in two.
Yeah, yeah, I caught that. Split brain. Hilarious. I'm ROTFL.

10:34 pm
Okay, okay. Don't freak out. I missed an entry, but it's
all good. I'M NOT SLIPPING. Just need some rest.
My head... I can't go on, I'll go on.

June 11

6:13 am

Woke up early. Just sitting here. I'm empty. Gonna do my best to follow the regimen today and keep up my writing, but I have nothing to say.

9:46 am

I can usually count on Leon to give me something, but he wasn't at breakfast today. So.... you get me. The equivalent of a blank page but with a gory mental head wound.

DUMB
=
NUMB

1:51 pm

Leon can tell I'm agitated, but he did me the courtesy of not asking too many questions. He knows when to leave me alone, unlike most people. But... he's leaving me alone for the game, which sucks. His little sisters are coming to visit. I don't like this disruption of my routine — not today. It's cool. I've got this.
I'm fine. I'm fine.

4:05 pm

Saw Carla burning something in the yard. Couldn't see what. She ignored my lame attempts at catching her eye. Yep. She's still pissed. And I'm still flatlining.

10:34 pm

Haven't seen HIM for a while. Makes me feel uneasy . . . like something's up.

June 12

6:34 am

Didn't sleep well at all. Blood is dripping everywhere. If I close my eyes long enough and breathe, I can make it go away. It's not real. It's not real.

9:55 am

Jesus, as if I needed another emotional sit-down to push me any further to the edge today. Gideon came to visit and not only did he say he's going to tell the feds about me, HE jumped at this chance to really fuck with me. I mean, look, I don't blame Gideon. He was just trying to get me to help him. He's under some serious fucking pressure with all this hack shit. His whole company is done. Burned to the ground. His livelihood. But then HE went all psycho, and this time HE wasn't taking out HIS violence on me — HE sliced Gideon's throat right in front of me. I know, I know, it's all in my head, but in the moment... I can't keep the blood from dripping out of the gunshot wound HE gave me <u>two days ago</u>. Shit, I'm trying... I'm holding on as much as I can.

Gideon didn't help things. Is he really going to tell the feds everything? Maybe that's for the best. I don't fucking know anymore. I only know I don't want anyone else getting hurt from this — least of all Gideon. Gotta stay focused for now, though. All this blood. It's everywhere. Can anyone see it? It doesn't matter, I'm putting a bandage on my head where HE shot me. I know. It's not real? But... it just feels... just feels like I need it right now. Feels better to put it on, so don't judge me, okay?

I am in control.
I am in control.
I am in control.
I am in control.
I am in control.
I am in control.

1:48 pm

Leon was being his normal self, but I could tell he thought the bandage was weird. Don't think he's buying my "I hit my head" excuse. Does he think I'm crazy too? Can everyone tell ??

HE was there harping on Gideon. HE thinks he's already ratted me out. There was a creepy dude staring at me all during breakfast. HE thinks the guy's a mole, put here to work me over. How do I ignore HIM? HE sees HIS way in — HE can feel the chink in my mind and it's cracking.

4:22 pm

Saw that weird dude again eyeing me from the fence in the yard. Is HE right? Are they on to me ?? No way, Gideon wouldn't... would he? I wouldn't blame him. I deserve everything coming my way.

10:29 pm

The bandage helps. It feels better knowing my brains can't spill out into my ~~brain~~ dinner even if... yes, I know.

June 13

9:42 am

Runny scrambled eggs. The food's really gone downhill. Guess it's all the cutbacks since Five/Nine.

11:51 am

Sorry for boring you with kitchen shit, but my regimen focus has got me started on a new approach that works doubly fast for drying — two-handed towel action. It's the little efforts like this that help me stay on track. Heading to lunch.

1:53 pm

HE's still not around. Saw Leon talking to Carla while I was dumping my tray. Wonder what they were talking about.

I don't remember.

10:29 pm

Gonna be hard to sleep. Everyone's talking about an fsociety splinter group that hacked Bank of E and forced Scott Knowles to burn 5.9 mil in public. I'm feeling that twitch under my bandage again.

Don't worry. That →
wasn't HIM up to anything.
It's where I tore the page
out for Carla's poem.

June 14

6:36 am

Well, with all that news last night, HE got riled up, which meant HE decided to keep me up — lecturing about the failures of our banking system. You would think that topic coulda put me to sleep, but HE can really project when HE wants to.

1:57 pm

Haven't seen HIM since this morning. Going to the game. Again. And again. Today began just like every other day, and the loop continues. Routine. Boring. Gotta stay on track.

4:19 pm

As if I didn't already have enough on my plate today, I've somehow nabbed the attention of The Warden, Ray. He came around all friendly and wanted some computer help. Weird. What's he got, an Etsy page where he sells office supplies he steals from work? I guess he doesn't have a lot of other hackers in here, so he's trying to get some free IT labor. Don't worry. I abstained. I do love his dog, though. Maxine. She has amazing eyes.

8:33 pm

Leon was curious what Ray wanted with me. I could tell he was fronting and trying to play it cool, but I got the sense he really, really wanted to know. I just told the truth for once: Ray wanted computer help and I said I'm outta that game. Leon nodded, but I could see his wheels turning. Maybe he doesn't trust Ray—you know, he is the law and all.

10:34 pm

Going to sleep.

June 15
6:33 am

I am in control. Control is not an illusion. Feel like I might have to start saying that every morning. I slept like a fucking rock. Hardly knew where I was when I woke up. But my head hurts again. Maybe just one more day with the bandage . . .

9:56 am

I think George is Leon's favorite Seinfeld character. He loved "The Tape," the episode where George becomes obsessed with Elaine because of her sexy talk. Who isn't obsessed with Elaine, am I right?

1:51 pm

Maybe I'm pulling outta this. Maybe things are looking up. It helps that HE's been leaving me alone. Gonna go check out the game.

8:23 pm

Some shit came up today and I missed a few entries. Fucking HE took over again last night while I was sleeping. Thought I was past that—thought it was under my control. HE loved rubbing it into my face that HE could still do it.

HE wants me to feel helpless. <u>FUCK HIM</u>. But what's worse is now HE's got me in with the Warden, Ray. In HIS conniving attempt to get me back on a terminal, HE told Ray I'd help with his site. We had a big blowup about it and HE tried the old gun trick on me again. But this time. . . I wasn't scared. That's one thing I can see clearly now. HE's scared. That's why HE's getting so desperate and pulling out all the stops. So I told HIM - give me what I want or keep shooting me. The look on HIS face was pretty fucking good. I laughed right at HIM. It felt good. Going to church group. Jesus, I'm fucking tired.

June 16

11:something? am

I hardly know what time it is. . . HE stole from me again last night — and how do I come to, you ask? On the fucking phone (with. . .) I can't even write it. Now that I'm talking to you again, you heard it. Didn't you? Did you hear what I heard? Was it real? Was that really him? And then. . . Gideon. NO. I CAN'T. I have to stop it. Have to stop these thoughts about him. I get too emotional and it'll be the thing HE needs to crawl through the cracks. But I have a plan. Gonna talk to Leon and get some Adderall. I need it to stay focused and try to regain some control to keep HIM away. I can't sleep. Can't give HIM any moments while I'm at rest to take over. Have to keep vigilant.

1:54 pm

Leon's down. He's getting what I need and didn't ask any questions.

After reading this several times, I'm pretty sure I know who he means, but like I said, if he's not writing it, neither am I. You have to figure it out for yourself.

One other thing... now that HE's shown HE can still take over, its made me wonder if HE was doing it all along and I just didn't know. I wouldn't put it past HIM and there's something HE said that keeps nagging at me. After the whole Santos/Reynaldo fiasco, HE said, "Santos wants more from you than a rat to nail." I'm pretty sure HE meant... HE took over and told Santos about Reynaldo. I gave up the rat. I'm the rat.

3:56 pm I still don't know how to deal with this. In order to block out any guilt and keep my mind in check, I put every ounce of focus on that basketball game. I asked Leon a million questions about the rules on each play just to keep my mind occupied.

10:26 pm
I'm just sitting here watching the minutes tick away till darkness. Alone. With HIM. If that really was you-know-who on the phone, maybe he really is in Dubai or wherever the fuck??? It seems too easy.

June 17
 1:45 am
I'm writing to do something to stay awake. But I have nothing to say. It's so dark I can't even read what I'm writing.

2:28 am
Staying awake like this is even worse than letting HIM take over. Not really, but I just have to sit here, alone, with my thoughts. What if that call was fake? What if I'm a murderer? What if he's waiting to kill me when I get out?
 What if...

4:34 am

I tried reading the fucking Bible. So, now here comes a real freak idea. The Bible's kinda good. I mean, for a sci-fi book. There's some mad vengeance God takes out on people. Dude doesn't like to get betrayed and I'm down with that. The plagues and locust shit and that heathen woman, Lot's wife, turning to salt—pretty fucking funny. Can't deny he's got a sense of humor. And a real ~~flare~~ flair for the drama. Gonna go to sleep now.

SLEEP TIGHT WHILE YOU GET YOUR LESSON
OF THE DAY FROM YOURS TRULY:
HOW TO DRAW A CAT!

FIRST DO THIS: THEN THIS:

9:47 am

Leon says he'll have the Adderall for me by this afternoon. I can keep on keeping on till then . . . I think.

1:43 pm

Leon wasn't at lunch. Maybe he had to go do what he had to do to get his supply. I sat at the end of the table Hot Carla was at. She's real good at ignoring. I wish . . . I could really use someone to talk to right now and I know she can't be down with being on her own all the time.

3:47 pm

I GOT THEM. Leon brought them to me at the game. He's worried about me, I think. HE had plenty to say about it being a stupid idea, but I told HIM it's all HIS fault and I'm going to stop HIM. Then proceeded to down a whole bunch right in front of HIS face. It's the only way— I can't think about Gideon. I can't think about anything. So I'm not writing any more today.

June 18
6:31 am

Just checking in. It's working. Awake all night and feeling good. Haven't seen HIM either. Read more of the Bible. I zoomed through lots of chapters or books, whatever they're called. This shit really does work. Going to breakfast even though I'm not hungry at all.

9:53am

Leon is fucking hilarious. When I really sit and listen to him, god, guy's a genius. He told me all about the muffin-top episode of Seinfeld. Elaine is so right! The tops are the best part.

5:57 pm

Well, it's the end of smooth sailing. HE decided to pull out ALL the fucking stops and attack with full force. HE tricked me into thinking Tyrell was coming for me. That he sent his henchmen after me. It was the most terrifying thing that's ever happened to me. HE's graduated from gunshots to hijacking my entire world. It was a layer in a layer that fucking wound itself up crazier than a Pakula movie. I had no idea which way was up until I finally figured it out. HE wanted the pills, forced me to puke them up, but it was my turn to freak HIM out. I just grabbed them right out of my own vomit and put them right back down. FUCK HIM. HE can't own me. I will not be owned.

PILLS

VOMIT

June 19
6:30 am

I'm firing on all cylinders. This is what it feels like when those people talk about bouncing out of bed in the morning. I'm up and ready to face the day. Is this what happy people feel like naturally? Haven't seen HIM since the vomit session.

Think HE's fucking scared. HE went to all that trouble. Pulled out all those stops for nothing. HE can't stop me. HE's just a bunch of smoke and mirrors without me.

9:47 am

I saw Hot Carla talking to some new guy today at breakfast. Who does he think he is just flat-out talking to her like that? She even laughed once which really pissed me off. That guy is just waltzing in and getting all chummy so easily. Bullshit!

4:18 pm

After lunch I decided to follow Carla and this new loser since they were hanging out AGAIN. They just went to the library. So I did too. I didn't want to go to the game anyway. I have all this energy to focus, so I might as well be learning something. I grabbed like three books on the cosmos and camped out at a table where I could stare right at Carla and the guy. I pretended to read and, after a while, they left anyway.

It's sorta hard to really explain how lasered in I am on these pills. Not sure it makes me as interesting as I think I am. I won't bore you with anything else from the rest of today.

June 20
6:32 am

Day three of no sleep. I'm up to 200 mg. Is that a lot? I think it's a lot. Definitely above the prescribed dosage. I feel like there is smoke coming out of my pencil. I'm writing so fast. It's pouring out and I'm just trying to keep up. HE's gone. HE's gone. HE's gone.

Of course he made this about him... I was just trying to forget for a while and that guy made me laugh for a second.

I tried to make sense of this.
I wonder who Shayla is?

...working lke chrm

Krmer NJfu ASD qxi George #//eAPtgsjjj five @BcTfqxi

HE's gone ...gne ... gnome

Morning Am? Wow /# Xi saw a braw pand at TPC rpxgg//:

Dgkt vluvod Slayha imms the hwey I gld klak ta ehr.

Trastinsg ot Ksithn witon kiamng eshsse. Ma i? Tish

Si artgnsit to gle letk a gucikfn diae tpiri Im

yildineet tno magikn essen tryih now. JBt htats

bkya. vo jve ntb ppdessuo to qwyaas kmae ngese

htrilg? hWb ssay higintevre.s dogft aekm neses?

Hhuh? huN emtas eht eulrs udnra rehe? Nto

ojo. ehetr aer no lvers. uResl rae ofr ecskrus.

mmmttm... F awtw a ololplip.

Nrleek panci. neerkl panci. neekrl npciq. lekern ncpiq.

mekle icpan. enrlke icapn. neeklr vpica. kerenl

opnai //: LNN X XKLM LFMNO

ASDF Q L :) EXN —X@

TKLMN LOL VNJ FN WYNN

V ajb etc. nyc ba na 44 z

! vmfao qn y zz k e:(// Lex.

jpr n 32 rs qush fapng y

asdfak li) N b 6 exe) i *

4 28 X 0 lol ny 238 —axa

dbf //ec 85 jggg jjjjjj

iii qXeu

```
[3448015.307991] [<ffffffffa0145c3b>] ?
:ext3:ext3-ordered_write_end+0x73/0x110
[3448015.307991] [<ffffffff80265486>] ? generic_
file-buffered-write+0x1c0/0x63c
[3448015.307991] [<ffffffff80231409>] ? current_fs_
time+0x1e/0x29
[3448015.307991] [<ffffffff80265c41>] ?
_generic_file_aio_write_nolock+0x338/0x3a9
[3448015.307991] [<ffffffff802419a1>] ? hrtimer_
wakeup+0x0/0x22
[3448015.307991] [<ffffffff80265d0c>] ? generic_file_
aio_write+0x61/0xc1
[3448015.307991] [<ffffffffa014228e>] ? :ext3:ext3_
file_write+0x1b/0x94
[3448015.307991] [<ffffffff8028a128>] ? do_sync_
write+0xc9/0x10c
[3448015.307991] [<ffffffff8023b699>] ? autoremove_
wake_function+0x0/0x2e
[3448015.307991] [<ffffffff80242079>] ? ktime_get_
ts+0x22/0x4b
[3448015.307991] [<ffffffff8028a8d9>] ? vfs_write+
0xad/0x156
[3448015.307991] [<ffffffff8028a864>] ? sys_pwrite64+
0x50/0x70
[3448015.307991] [<ffffffff8020b528>] ? system_call+
0x68/0x6d
[3448015.307991] [<ffffffff8020b4c0>] ? system_call+
0x0/0x6d
[3448015.307991]
[3448015.307991]
[3448015.307991] Code: 30 fa 58 80 4c 39 2c 08 75 04 08 0b
eb fe 48 c7 c0 40 fa 58 80 eb 18 65 48 8b 04 25 10 00 00
00 66 87 80 44 e0 ff ff 00 ff 75 04 <08> 0b eb fe 48
c7 c0 30 fa 58 80 48 8d 1c 08 48 83 3b 00 74 04
[3448015.307991] RIP [<ffffffff8037fc7c>] xen-spin_wait+
0x90/0x139
[3448015.307991] RSP <ffffffff80595e28>
[3448015.307991] ---[end trace 604fbc4ae1a5e660]---
[3448015.308075] Kernel panic - not syncing: Aiee, killing
interrupt handler!
```

June 24
 6:40 am
I failed. It was a stupid plan, I know, but I had to try
something. Now I'll have to sleep and HE'LL be back.
I also tried to throw you away— this journal that is.
I'm pretty sure I alienated anyone and everyone in church
group with a giant fuck-God speech. A lot of the past
few days is a blur, but when I say I tried to throw this
away, I mean I dumped this journal right in the trash.
But Ray brought it back to me. I'm pretty sure he read just
about everything in here. I have to flip back through and
make sure nothing's too incriminating. I think I've been
pretty careful. He didn't set the dogs on me, so I think
I should be in the clear. Maybe I'll go talk to him.
Maybe he knows another way to deal with my daemon.

11:43am
Went to see Ray. He definitely read everything, but seemed
mainly focused on HIM. I dodged and he let me. Then
we just played chess.
I'm definitely not worried about my regimen anymore. I
mean, I'm kinda keeping up with my schedule since I have
to anyway, but it seems like any plan I come up with
ends in failure.

June 24
 4:15 pm
Darlene came to visit. She's getting out of control and doesn't
want to listen to me. There was something she wanted to
tell me, but we got sidetracked by talking about HIM.
She said she wished she could talk to HIM and not
me. She thinks HE's the one who would understand
what she's trying to do. Do you think she really meant
it? She wants me to be like her. ANGRY. I am.
I just don't show it the same way she does. What was
she going to say to me ??
 That's low. For a while I
 thought I'd like her, but this... not cool.

9:24 pm

Played chess again with Ray. I asked him why they don't let Hot Carla serve her time in a women's jail. He can't just ignore that things aren't so good in here for her. Maybe he'll actually look into it like he said. I'd hate to see her go, but _even I'm not selfish enough to keep her here for myself._

Ray's not gonna let up about talking things out. But I already have a therapist, all right? Plus another lunatic who won't even let me consider the idea of coming clean, aka HIM. HE got super hot and bothered about me even entertaining the thought. Of course, that got me thinking. Why don't I just come clean to Ray? Tell him everything? HE does have an argument that it might not sit well with the DA if I get busted for confessing. Anyway, I don't have to decide that now. Instead, Ray gave me a chessboard and said it would be good for me to play myself. So I guess I'll give it a try.

10:57 pm

It's past lights-out, but I can't sleep. I was gonna take Ray's advice and set up a game to play myself and HE came up with an offer... a challenge. HE wants us to play each other for total control... of me. Whoever wins gets total autonomy _FOREVER_. Can I trust it? Can I risk it? It sounds crazy, but I said that from the beginning of being here: I have to fight crazy with crazy. Maybe this is finally the way to be rid of HIM forever.

June 25

6:34 am

I didn't sleep at all last night. I don't know what to do and can't stop thinking about it.

9:43 am

Been looking around at everything with a whole different perspective. I watched Carla eating her breakfast today with that new guy. Found out his name is Charlie. They were laughing and talking, and I wished that was me. I don't remember the last time I laughed. If I lose to HIM I'll never get the chance to make things right with her. That'll never be me sitting there with her.

11:47 am

So I brought up HIS challenge with Krista. She seemed pretty concerned and wanted to speak to HIM. I wasn't going to let that happen. HE hasn't touched my relationship with Krista, and I want to keep it that way. She's against this game, I'm pretty sure, but she's got it all wrong. She said annihilation is not the answer, but it's the only answer.

1:45 pm

I just let Leon in on the fact that I'm evaluating the value of my existence. He had a lot to say on the topic. He said I should dream on it. Take a look into the life and future I'd be fighting for and see if it's worth it.

11:58 pm

I did it. I took a look into the future fairy tale and saw everything as it could be. As I want it to be. There has to be a way that even one-tenth of it could be real one day. And if there is even a small chance that even that small amount could happen, I want to be around to see it.

So game on, motherfucker.

June 26
9:41 am

Had a nice breakfast with Leon. He asked if I dreamed on things and I just told him it's been nice knowing him. Think that pretty much freaked him out, but I didn't have much else to say. My existence is on the line, and anything could happen when it comes to HIM.

1:33 pm

Went to the library just before rec time and found Carla there. She was alone. Just in case it was the last time I would see her, I wanted her to remember me as me. So I gave her a copy of Catcher in the Rye. Don't give me any shit about it being too clichéd. It's my favorite, and giving someone that to read is almost as personal for me as giving them this journal. I didn't say anything. One thing Holden says says it all for me. I don't remember the quote exactly, but the gist is: If you start talking to people, it'll just make you miss them when they aren't around.

So I just gave her the book and walked away. I hope I see her again.

4:23 pm

WELL, it turns out all the drama was for nothing. HE set me up. This whole fucking exercise was HIS conniving way to yet again trick me into giving up the fight. EVERY single game ended in a stalemate. I still reject HIS argument that we are the same. HE is not here to help me, HE is here to help HIM get whatever HE, and only HE, wants.
I will not let that happen.

HE WON'T ACCEPT THAT HE HAS NO CHOICE. IT IS WHAT IT IS, AND THAT'S ALL HE HAS TO COME AROUND TO. WE ARE IN THIS TOGETHER TO THE END.

CROSS ME OUT. IGNORE ME. TURN A BLIND EYE TO WHAT YOU'RE AFRAID OF, MAKE IT GO AWAY. IT DOESN'T MAKE IT UNTRUE JUST BECAUSE YOU REFUSE TO BELIEVE IT. I WILL <u>NOT BE ERASED.</u>

For once I'll align myself with the US government. I refuse to negotiate with terrorists and do not feel the need to respond to their claims or threats.

10:51 pm

Just got back from Ray's. I got an emergency message from Darlene: ⟦init 1⟧ I called her and found out we might be in some deep shit. Our friend is dead. That's what she wanted to tell me the other day. She must have thought I couldn't take it after Gideon. I don't know if I can. The bodies are piling up all around me.

So... there was only one choice I could see and I saw it very clearly. For the sake of everyone I care about... I had to completely break my abstinence from technology.

I told Ray I changed my mind and I'd help out on his site. Lucked out that he didn't ask any questions about why and he just let me at it—with one caveat. He doesn't want me poking around too much. Yeah, yeah, scratched my brain too, but I have bigger things on my mind and, anyway, I'm a changed man — or at least trying to be. Needless to say, HE couldn't be happier.

June 27
6:38 am

I have more work to do at Ray's today. The added bonus is it gets me out of my boring kitchen and laundry duties. Need to send my work to Darlene and then it's on her to follow through with the rest.

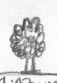

SLIPPERY
SLOPE

9:47am
Leon's been curious about why I've been spending time at Ray's. I've been able to put him off it, just using my cover of helping him with his site. Leon seems unsure and worried, but he only sticks his nose in so far. He said it must feel good to be back online, though. I hate to admit it but... it does.

12:01pm
Like I said, it feels good. All the old feelings come rushing back. Along with that, though, comes the curiosity. For better or worse, I asked that dickhead Lone Star—who Ray has on me as a babysitter—if I could meet the old sys admin. There are some minor roadblocks to the migration that I wanna talk through with him. That's the excuse I'm using on Lone Star and Ray. But... I know that, deep down, I want some answers about this site. I'm taking the long way around getting to them, hoping that'll keep me from getting in too deep. It's like an ex-alcoholic who starts walking past the liquor store on their way home instead of going two blocks over. It's only a matter of time until they go inside, but they keep kidding themselves for just a little bit longer that they can hold out. But hey, at least I recognize it. I'm only halfway in denial.

1:47pm
I saw Carla reading Catcher in the Rye at lunch today. I like to think it's a little sign to me. ... I dunno. Might just be all in my head and she just wanted to read it anyway.

4:07pm
Went to the game today. It was nice to get a little time outside since I've been cooped up in Ray's office. Leon finally watched the Soup Nazi episode. Surprisingly, it wasn't one of his favorites. He said it was pretty funny and all that, but he said he's worked with someone like the Soup Nazi—the

kind of person who doesn't allow for any deviating from their organized structure and time schedule—and those sorts of people bug the shit out of him.

8:47 pm
Carla found me tonight. She handed me a torn-out page from Catcher in The Rye. It was a little burned at the edge, so she must've saved it from her flames. It was from the part where Holden takes Phoebe to the zoo. I think I woulda picked that one too. Couldn't help it. Had to save that page. It's just too good.

10:23 pm
HE was waiting for me back in my cell. HE's got some serious reservations about me digging into Ray's site. I played innocent and said I just needed to talk to the sys admin about the migration. Obviously HE knew I was lying, but there's not much HE can do.

June 28
4:46 pm
Let's not make any comments on my sporadic journaling, okay? I'm still keeping HIM in check. I just don't feel the need to blab about it all day long all the time. Besides, I blab to you all the time now anyway.

Darlene's trying to pull Angela deeper into things. She wants her to help onsite for our thing. Angela's no dummy. She's gonna start putting two and two together here, and if she gets the whole picture, it's going to get ugly. Angela is not someone to fuck with, and she's gonna feel very, very used and abused by us. She never should've taken that CD. What were the odds that she and Ollie would be the ones? And I don't want her involved in any more steps of this shit. She still has a chance to claim innocence, but not if she actively has a role in what we're about to do. I have to protect her from what I've already done.

June 29
6:31 am
I haven't been able to get on Ray's computer again to see if Darlene has come up with another solution. I'm worried she's not going to listen to me and will find a way to convince Angela. HE thinks I'm being a pussy, of course, but HE also wanted to blow up a gas line until I found another solution.

9:47 am
Hot Carla seemed to be in a really good mood this morning. She walked by Leon and me and dropped one of her pancakes on my tray. That made me happy until... I saw track marks on her arm. I freaked and was about to go confront her when Leon stopped me. He said I'd told him whatever was worked out was between him and Carla. He said all I needed to know is that he got her what she needed. She's all good. He was able to get her the hormones after all. I know I should learn my lesson and leave people alone, but this just seemed like an easy fix for someone who rarely gets an easy anything.

4:10pm
Ray gave me the go-ahead to meet with R.T., the old sys admin. I found out everything. Anything and everything humanly corrupt can be bought and sold on Ray's site. There aren't even enough words for "bad" to describe the shit I saw. I don't know why I have this compulsion to always look behind the curtain, but I do. I have to know the truth. And it's almost always not good. BUT... something's different this time. Despite falling for my old addictions to know it all, I don't have to take the same next steps I always take. Unlike the old days, I'm gonna give someone a chance. I think Ray deserves it. This site might be the fucking devil's marketplace, but is Ray really the devil? Not the guy I know. But how well do we really know anyone?

Right here it sounds like Elliot shoulda known enough.

I AM STATING IT LOUD AND CLEAR: THIS IS A FUCKING BAD IDEA.

Duly noted and ignored.

10:03 pm

Leon could tell something's bugging me at dinner. I'm not gonna lie, I'm nervous about talking to Ray. There are many ways this conversation could go and most of them, well, they aren't gonna turn out good for me. Should I listen to HIM and just ignore it? How can I ignore what I've seen? Girls for sale. And I mean girls... young ones. Add on top of that drugs, guns, contract hits... I'm not the morality police, but if I can in any way put an end to this, I will.

Shit. I still don't know what's going on with Darlene's plan. I'm definitely starting to feel I've got too many balls in the air. There's a sinking feeling—I'm falling—back into my old ways. No. I'm not. I'm stronger now. It will work out.

June 30
4:15 pm

Well, it looks like there's nothing I can do to stop Angela. She came to visit me. You don't really know how much you miss someone until they're sitting in front of you. I told her not to help Darlene and me, but that's just what pushed her over the edge to do it, I think. She says she wants to help me for a change. It's almost funny that she thinks it's the other way around. I feel like I've caused her nothing but trouble lately. Anyway, there's not much I can do to keep her out of things from here. She's gonna make her own decisions no matter how much I warn her of the danger.

I guess that pushed me even further to give Ray his ultimatum. With the migration stopped, I hold the key to his future— and there's only one way out of this for him. I'm not playing God, I'm just trying to be the angel on someone's shoulder for once. He actually heard me out. I think he was being truthful when he said he had no idea what was on his site. I do think it's possible for people to get in over their heads. Shit, I know it firsthand. So I gave him the choice. I told him to shut it down or I'd end him. Guess it's a ballsy move, seeing as he has all the power in this place. HE thinks I've gone off the reservation, but I'm putting my faith in Ray.

July 6
6:35 am

After what I've been through, you'll understand why I've been gone. Everything I thought was wrong. Everything except having faith in Ray. He was in over his head and just didn't know how to stop it. So I took a lot of shit for it— a lot— but I helped him in the end. Ray was right, I wasn't looking enough moves ahead and even when I did, he was already there, waiting for me. He let it happen. The site's down, and now Ray and Lone Star are in the custody of the FBI and I'm free of their threat. That's not all I'm free from. During our time in solitary, HE and I came to an understanding.

HE told me everything. Tyrell isn't in Thailand. He isn't in an ice castle. He isn't drinking from a coconut. I've said it before and I'll say it again, the truth I find is rarely good. This time wasn't any different. But I'm different now. WE'RE different. That's what we are... WE. We have to do this together or we can't do anything at all.

9:53 pm

I'm so tired. So much has happened and it's all in these pages here. I thought keeping this regimen was going to be my answer to everything, but it was just another long-winded way of coming back around to the truth about myself. Maybe I needed to go through this. Maybe I needed to take this path from point A to B to J to X and back again. I am who I am. I created HIM as a part of me. I can't get rid of HIM. I'm not going to try anymore. So I don't need this anymore. And I was wrong about you reading it. I don't need you to.

This only belongs in the past.

That was his last entry. When he took off during the riot, I grabbed the book from the fire and hid it in my cell. I never did that before. When I burned a book, it BURNED. Until now, that is. This didn't need to be changed. It needed to be found.

Around the time Elliot got out, Leon was gone too. He left a phony business card in my cell, for Art Vandelay, Importer/Exporter. It has an email on it, but I've never tried it. I kinda felt like it was emergency only and things haven't gotten that bad... yet.

Santos got discharged as part of that same offenders-release program that let Elliot out — because of the Five/Nine cutbacks and prison overcrowding. But, fucking idiot that he is, he wound up right back in two weeks later for murder. Apparently neither he nor his wife were very faithful to each other.

And we all know what went down with Elliot after the events in this notebook, but what's here still fills in some missing pieces. In fact, I would say this book is one whole piece in the gazillion jigsaw puzzle set that makes up Elliot Alderson. And that's why this had to be released. Because I hope one day the puzzle gets put together. And I hope one day I get to see it.

As for me? Well, I'm out and free and, unlike Tyrell Wellick, I will be sipping on a coconut real soon. Only one person knows how to find out where I am, and that's between him and me... if he ever wants to find me.

Like I've said before, there were a few things during this time that seemed off to me. Was HE up to something?

- **Random Envelope:** This was from that weird blank letter Elliot got. He used this as a bookmark.
- **Page from Resurrection:** He was weird that day... or was HE? Anyway, I saw him trash this, so I nabbed it. I remember Elliot saying a few pages were torn from the book.
- **Wellick sightings article:** Elliot went to a lot of trouble to get this, but maybe HE was looking for something else...
- **Church group pamphlet:** Someone left this in Elliot's cell — I'm not sure who. Like everything, I decided to keep it.
- **Letter:** Another thing I saw him (or HIM?) throwing out. From what I know about Darlene, this doesn't sound like her at all.